ECCLESFIELD, CHAPELTOWN & HIGH GREEN

From Old Photographs

ECCLESFIELD, CHAPELTOWN & HIGH GREEN

From Old Photographs

JOAN *&* MEL JONES

AMBERLEY

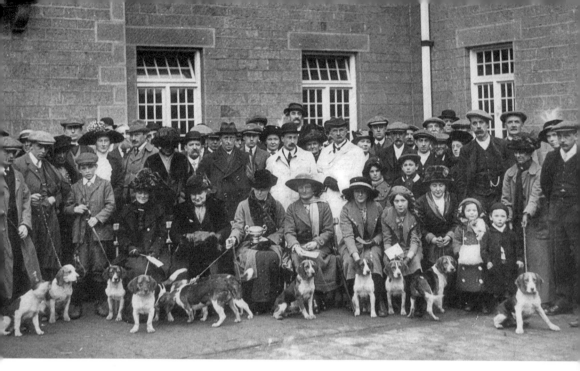

Ecclesfield beagles and supporters outside the stable block at Whitley Hall, Ecclesfield.

First published 2014

Amberley Publishing
The Hill, Stroud, Gloucestershire, GL5 4EP
www.amberley-books.com

British Library Cataloguing in Publication Data.
A catalogue record for this book is available from the British Library.

ISBN 978 1 4456 1826 5 (print)
ISBN 978 1 4456 1834 0 (ebook)

Typesetting by Amberley Publishing.
Printed in Great Britain.

Contents

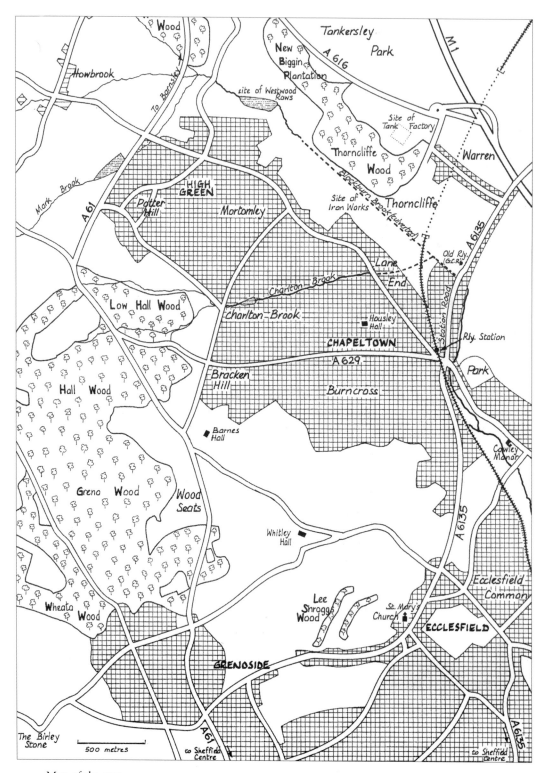

Map of the area.

Introduction

To the casual visitor, the northern suburbs of the present-day Sheffield Metropolitan District, which include Ecclesfield, Chapeltown and High Green, are indistinguishable from the outer residential districts of other large, urban areas throughout the country. They contain extensive areas of semi-detached and detached houses and bungalows, largely of brick with tile roofs, intermingled with woods, stretches of farmland, parks and playing fields, modern industrial complexes, and cut through by a number of important roads containing ribbons of retail shops. However, further exploration reveals that embedded in this suburban sprawl are what were once the three separate village communities of Ecclesfield, Chapeltown and High Green, together with a number of smaller settlements – such as Charlton Brook, Burncross, Whitley, Bracken Hill and Warren – that once had their own individual identity and character. Even today, these old settlement cores are easily recognised by their building materials – coal measure sandstone and millstone grit.

All these settlements were once part of the ancient ecclesiastical parish of Ecclesfield, which, before its break-up into a number of smaller ecclesiastical districts in the nineteenth century – including ones at Grenoside, High Green and Chapeltown – was one of the largest parishes in England, covering nearly 50,000 acres or 78 square miles. This extensive parish was served by the parish church of St Mary, standing proudly on its eminence in the village of Ecclesfield, together with chapels of ease at Bradfield (now St Nicholas' parish church in the separate parish of Bradfield) and at Chapeltown (in the Middle Ages Chapeltown was simply called Chappell, after the chapel there).

For hundreds of years until the mid-twentieth century, the area relied on the exploitation of the physical resources within its boundaries: the land, woods, stone, coal, iron and power generated from its small streams and brooks. At an early date, these gave rise not only to farming, quarrying, coal and ironstone mining and woodland crafts but also to a tradition of iron production and light metal trades. Villagers not only cultivated the land and kept livestock but would often also have had a second occupation. In the seventeenth and eighteenth centuries, the most important of these was nail making, which was replaced by hand file-cutting

in the nineteenth century, which in turn disappeared in the face of competition from machine-made files. Nail making was a domestic industry carried on in a nail-making smithy, which was often converted into a file-making workshop. A small number of these still survive in Ecclesfield.

Eventually it was coal mining, foundry products, engineering and chemicals production, together with the inexorable growth of Sheffield and the suburbanisation of its population, that transformed the landscape of the area and turned the once separate villages and hamlets into the interlocking, cosmopolitan residential communities of today.

This selection of 180 fascinating photographs from the collection of the Chapeltown and High Green Archive, including old favourites and others never published before, provides a comprehensive visual history of the area. The photographs cover not only settlement history but also social and industrial history. These images and informative captions will be of interest to long-established residents and relative newcomers to the area alike.

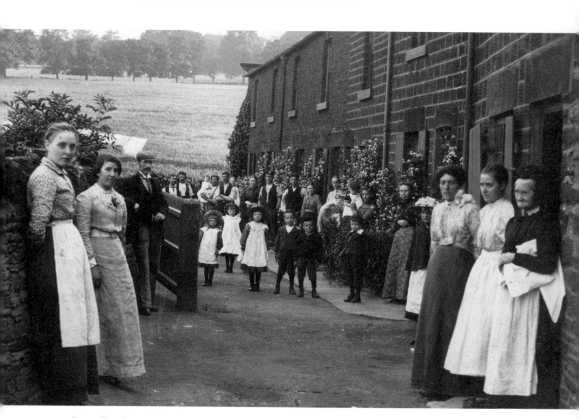

Sweet Pea Row, Burncross.

In the Beginning...

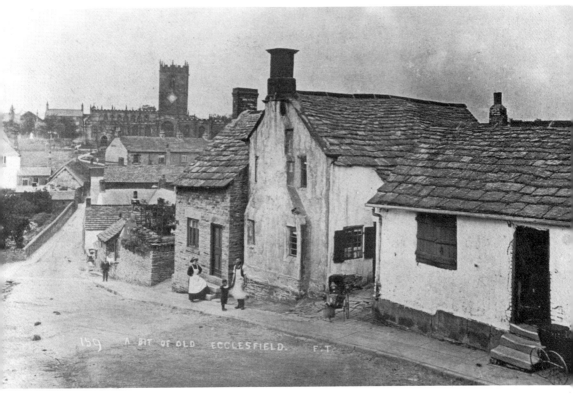

This view of St Mary's Lane, Ecclesfield, was taken more than 100 years ago. Dominating the scene in its elevated position is St Mary's church, once known as the 'Minster of the Moors' on account of the large parish that it once served, which stretched westwards into the Pennine fringe as far as Bradfield and Bolsterstone. Ecclesfield was first recorded in the Domesday Book in 1086 and means a Christian church (eclesia) in a treeless area in an otherwise well-wooded landscape (*feld*).

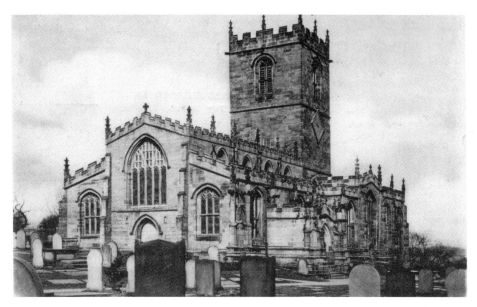

St Mary's church, Ecclesfield. This magnificent church resulted from extensive rebuilding in the Perpendicular style at the end of the fifteenth century, although a church had stood on the site since at least the twelfth century. Inside there is a monument to Sir Richard Scott and stained glass windows dedicated to children's authors Mrs Margaret Gatty and her daughter Juliana Ewing. Buried in the churchyard are Joseph Hunter, the renowned local historian, and Alexander John Scott, Nelson's chaplain and secret agent.

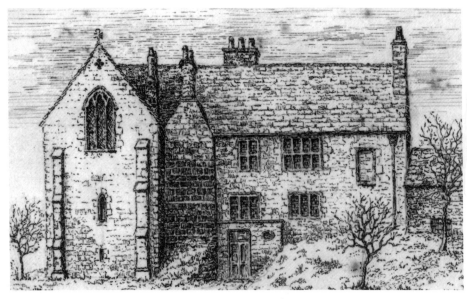

Ecclesfield priory. The Benedictine priory, here portrayed in a drawing by W. G. Fox dating from 1887, still survives close to the church. It was built to accommodate the monks of St Wandrille's Abbey in Normandy, who were granted the church and land in Ecclesfield parish by the lord of the manor. It was first recorded in 1273. In the fourteenth century it passed to St Anne's priory of Coventry. After the Dissolution of the Monasteries it was converted into a dwelling house, which it remains to this day.

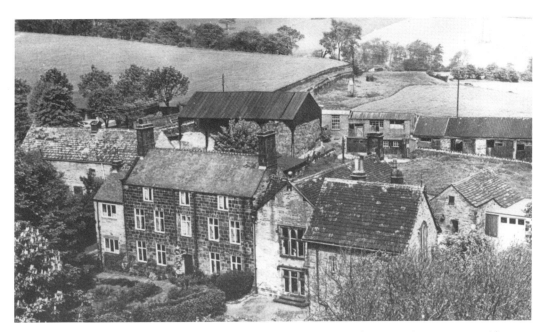

Ecclesfield Hall. This five-bay hall was built as an extension to the priory in 1736 to provide more commodious accommodation for a farm tenant. It replaced an earlier extension to the priory built in the Tudor period. The hall was the scene of strange accidental deaths in 1859 when the occupier, eighty-year-old Samuel Greaves and his seventy-six-year-old wife, Mary, died after eating monkshood, which Mary had picked, thinking, it is assumed, that the poisonous roots belonged to an edible vegetable.

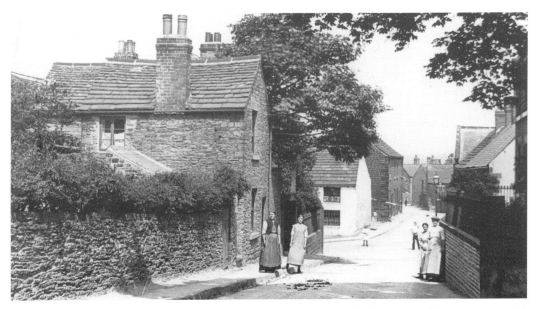

Yew Lane. The village scene in Ecclesfield shown here was captured when every village street was much quieter than today. The only clues that traffic ever passed along the lane are the horse droppings. In her story *The Yew Lane Ghosts*, published in 1865, Juliana Ewing, the Ecclesfield-born children's writer, described it as 'cool and dark when the hottest sunshine lay beyond it – a loitering place for lovers – dearly-loved play-space of generations of children on sultry summer days'.

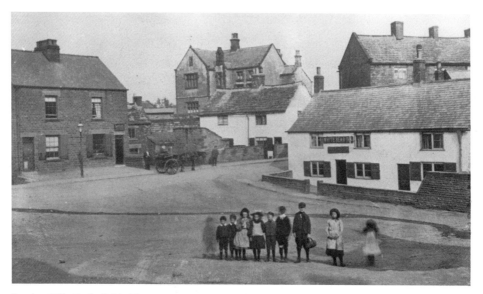

Stocks Hill, Ecclesfield. This open space near the church was where the annual Whitsuntide Sing took place. It was also the place where the village stocks were located. Convicted drunks, brawlers and minor thieves were locked in the stocks, often for several days and in all weathers. Stocks were last used in England in 1872. One ninety-one-year-old Ecclesfielder interviewed by a local newspaper reporter in 1932 said he remembered drunks being put in the stocks on Sunday morning for being drunk on Saturday night when he was a boy.

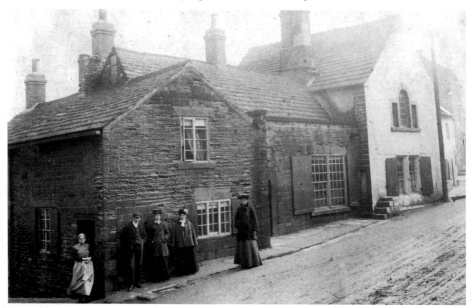

The Black Bull, Ecclesfield. Although this public house still exists in the same place on Church Street exactly opposite St Mary's parish church, the building shown here was demolished soon after the photograph was taken and completely rebuilt. The Black Bull is the centre of the local Christmas caroling tradition, which is now more than two centuries old. Rehearsals begin at the Black Bull on a weekly basis every Thursday after Remembrance Day on 11 November, with a final performance at lunchtime on Christmas Day.

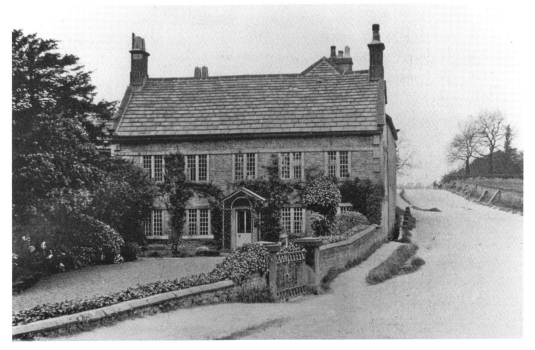

Above: Cowley was first mentioned in 1161, and means a woodland clearing where charcoal was made. Cowley Manor is a seventeenth-century manor house built by the Earl of Shrewsbury. It replaced an earlier manor house described in a seventeenth-century survey as 'a stately castle-like house moated about'. The medieval manor house was associated with two nearby deer parks, Cowley Park and Hesley Park. Cowley Manor remains a family home.

Right: Cruck Barn at Cowley Manor. Captured on camera shortly before its demolition is this ancient cruck barn in the grounds of Cowley Manor. The frames of cruck barns were made up of a number of naturally curved timbers (usually oak) that were sawn lengthways to make matching pairs of cruck blades. This cruck barn is said to have been used as the first nonconformist place of worship in Chapeltown.

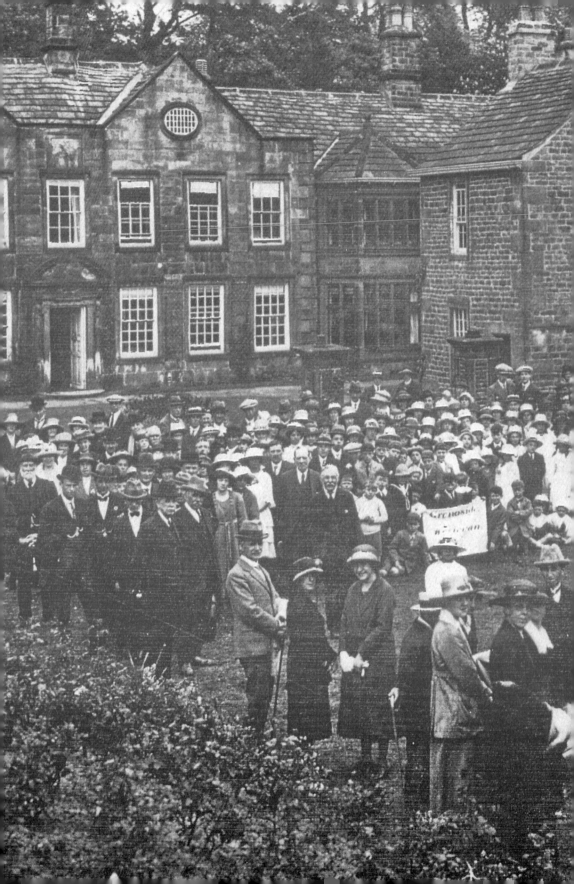

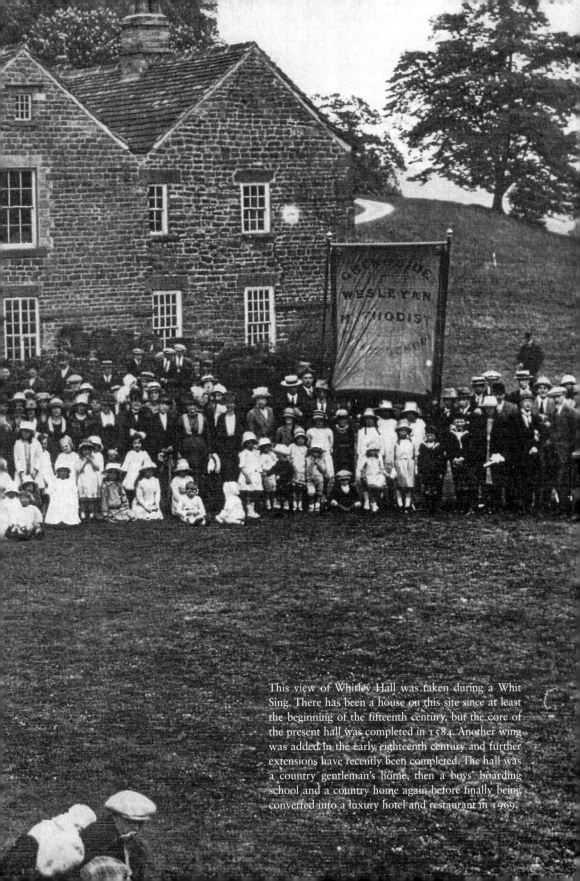

This view of Whitley Hall was taken during a Whit Sing. There has been a house on this site since at least the beginning of the fifteenth century, but the core of the present hall was completed in 1584. Another wing was added in the early eighteenth century and further extensions have recently been completed. The hall was a country gentleman's home, then a boys' boarding school and a country home again before finally being converted into a luxury hotel and restaurant in 1969.

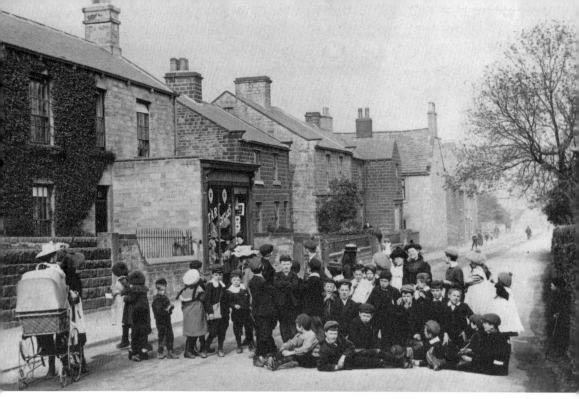

Above: Greenside, Chapeltown. The year is around 1900 and the photographer has set up his equipment in Greenside on the lower part of Burncross Road. And as usual this has attracted a large crowd of children, almost all the boys wearing a cap and almost all the girls a woolly beret. The shop on the left was owned by Edward Milns who ran a drapery at the front and a grocery store at the back. It is now a fish and chip shop.

Opposite above: Depicted here in a drawing by W. G. Fox in 1887, Housley Hall (Housley meaning the house in the woodland clearing) was first recorded in a thirteenth-century charter. It was owned by Archbishop Rotherham and the Housley and Freeman families before being inherited by the Earl of Wharncliffe of Wortley Hall. At various times it has been the home of members of the Chambers family (of Newton Chambers), a boarding school, and a tenanted farmhouse. It has now been restored as a private residence.

Opposite below: Greenhead Almshouses, Chapeltown. Now occupied by a firm of solicitors, these almshouses were founded in 1837 by Mrs Lydia Freeman of Housley Hall. They were designed to be occupied by six persons, each having their own front door. The castellated area in the middle housed a communal reading room cum chapel. In the background can be seen Greenhead Wesleyan Reform chapel, built in 1865.

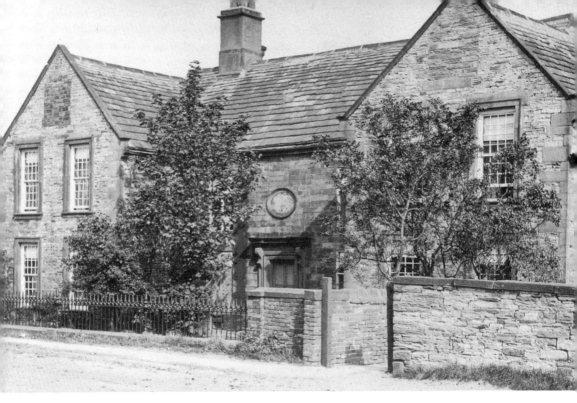

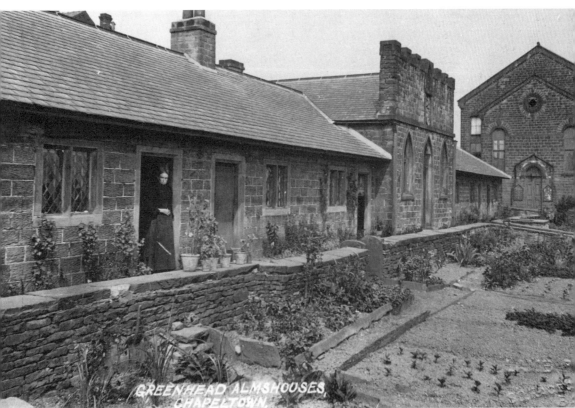

GREENHEAD ALMSHOUSES, CHAPELTOWN.

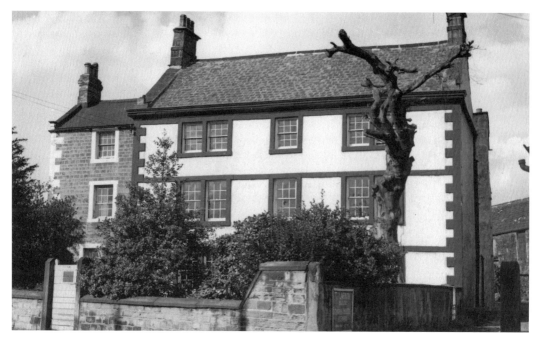

Chapeltown House. This grand house in the centre of Chapeltown, now disappointingly demolished to make way for a modern building (the Yorkshire Bank), was built in the late seventeenth or early eighteenth century. It was occupied by a succession of prosperous local families. These included the Allen family, who owned the house for 200 years, Matthew Chambers, grandson of the co-founder of Thorncliffe Ironworks, George Dawson, manager of the ironworks, and Charles Ellis, clothes retailer.

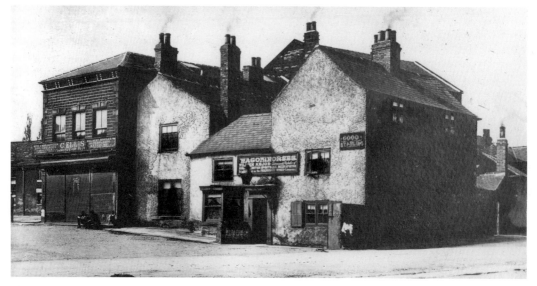

The Waggon & Horses, Chapeltown. Looking very different from the recently renovated public house occupying the same position is the Waggon & Horses of more than a century ago. Standing at the crossroads of the main road routes between Rotherham and Huddersfield, and Sheffield and Barnsley, it was in exactly the right position to intercept horse-drawn carts and wagons, hence the sign 'GOOD STABLING' prominently displayed on the wall. The landlord at that time was William Major.

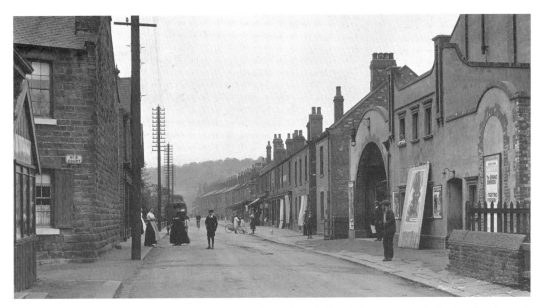

Station Road, Chapeltown. The quiet scene shown here belies the importance of Station Road to the residents of Chapeltown. Formerly known as Furnace Lane, it was renamed after the coming of the railway in 1897, leading as it did to the railway station on White Lane. On the right is the Picture Palace that opened in December 1912, and closed in March 1963. It still stands, having been used at first as a bingo hall and now as a snooker club.

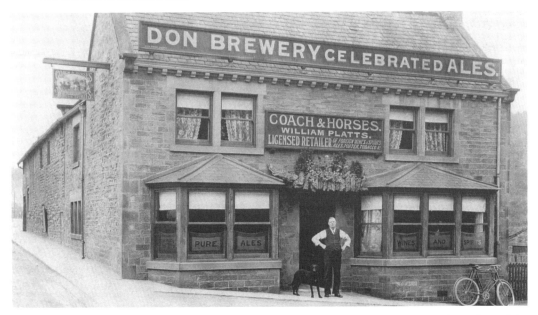

Coach & Horses, Chapeltown. The landlord, William Platts, stands proudly at the front door of the Coach & Horses on Station Road. Like the Waggon & Horses, this public house was (and still is) well located beside the very busy main road between Sheffield and Barnsley. But in William Platts' time there was another source of good trade in the summer each year. This was when the travelling fair (Chapeltown Feast) occupied the once open ground behind the pub, attracting very large crowds to the stalls, rides and sideshows.

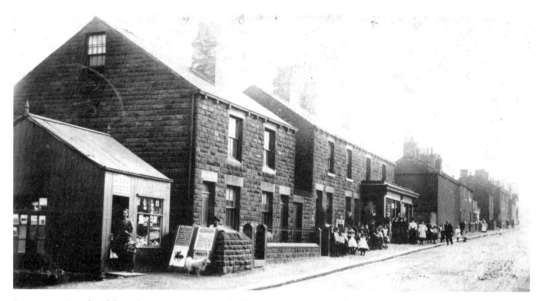

Burncross Road. Although now just a small district within the Chapeltown area, Burncross was significant enough as a distinct place in the distant past to carry its own name. The belief is that 'burn' is derived from *bere-aern* (barn), as in nearby Barnes Hall. The word 'cross' could have two possible meanings: it could mean exactly what it says, a wooden cross or a way-mark; or it could refer to the nearby crossroads where the present Burncross Road is crossed by Bracken Hill and Hollow Gate.

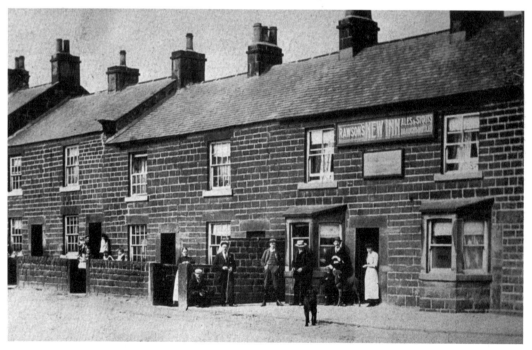

This view of the New Inn, Bracken Hill, and adjoining cottages is from the early 1900s. The New Inn was established in around 1863, but did not last long and closed in 1913. Mr and Mrs Arthur Marsden, landlord and landlady, can be seen standing at the pub doorway with their son, Charlie. Mr Bell and Mr Burtoft of Charlton Brook are by the wall.

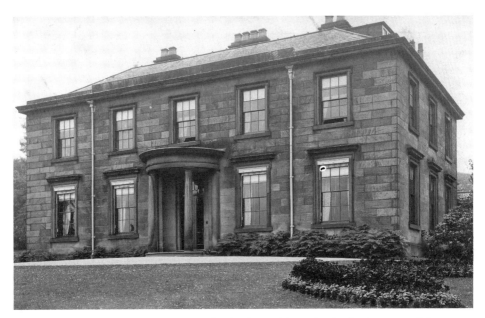

Barnes Hall. The name Barnes is believed to be derived from the Anglo-Saxon word *bere-aern*, meaning a barley house or barn. The present Barnes Hall was built by William Smith, formerly of Cowley Manor, in 1823. To make way for the new house, the old Barnes Hall of fourteenth-century origin was demolished. In 1891, the Smith family employed a butler, governess, housekeeper, cook and four maids. Later, Barnes Hall was the home of Lady Mabel Smith (née Fitzwilliam, 1870–1951), and Col. William Mackenzie Smith.

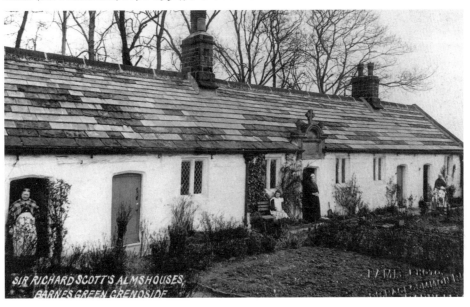

Barnes Green Almshouses. In his will of 1638, Sir Richard Scott of Barnes Hall directed that a hospital or almshouse was to be erected for six poor persons at Barnes Green. The almshouses were built in 1639 and stood alongside Elliot Lane. The scene shown here was photographed in the 1920s and shows Mrs Bibbs, a widow from Woodend, in the central doorway with her grand-daughter, Mary Mellors, sitting on the garden seat. The houses were demolished in around 1950.

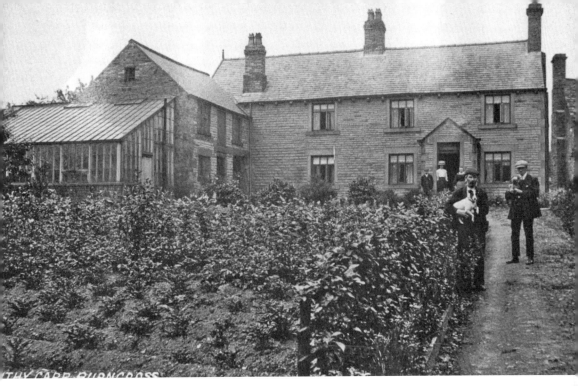

Above: Smithy Carr, Burncross. Now demolished, Smithy Carr consisted of a small group of cottages. The one shown here has a lean-to greenhouse and extensive cottage garden. Smithy Carr was first recorded in the early seventeenth century when it was said there was a cottage of two bays and a garden surrounded by a common called Smithy Carr Common. 'Carr' is from the Old Norse word *kjarr,* meaning a marsh, in this case where a smithy was located.

Opposite: Lound. This area of Chapeltown, like Smithy Carr, has an Old Norse name. This time it is *lundr,* meaning a small wood or copse. The area was first mentioned in a document written between 1200 and 1210. It is still marked on maps as Lound Side, but these stone-built, ivy-covered cottages with their stone-walled gateway have now been demolished.

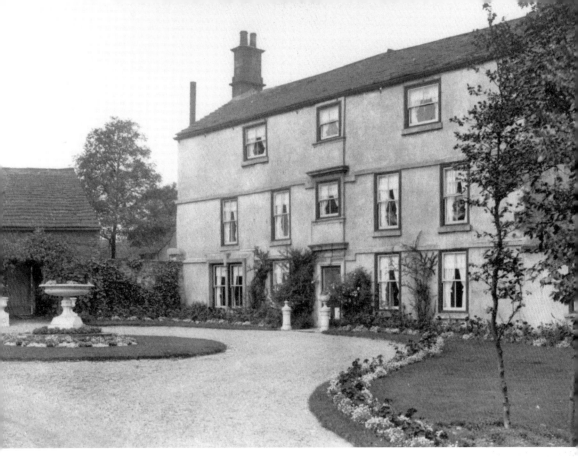

Above: Mortomley Hall, which was demolished in the 1960s, was built in 1703 by John Parkyn. It was built on the site of a much older manor house, the Parkyn Estate, dating back to 1567. The name Mortomley is Anglo-Saxon and is probably derived from the words *mor-tun-lea*, that is a clearing (*lea*) associated with a farm (*tun*) on the common (*mor*).

Opposite: Lane End Almshouses. Mortomley Lane End almshouses were founded by Edward Sylvester in the late seventeenth century. They contained seven rooms for seven poor men and women of the parish of Ecclesfield. The site is now occupied by part of Copley House.

Charlton Brook. Charlton in Charlton Brook first appears in 1453 as *chirkin* and *charkin*, which could mean squelching or charring (possibly the making of charcoal). In the second half of the nineteenth century, the Ogden family kept the Bridge Inn at Charlton Brook but were also charcoal makers, perhaps following an ancient charcoal making tradition. These cottages overlooked the dam and were demolished in the 1960s.

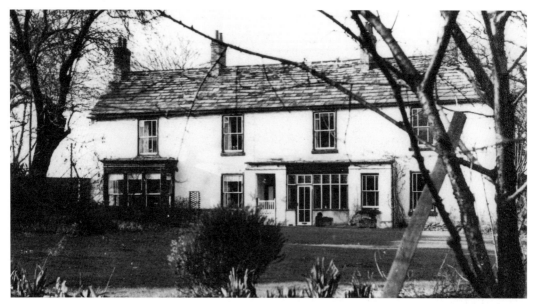

High Green House. High Green was first mentioned in Ecclesfield parish register in 1599 as *Hyegrene*. William Fairbank's map of 1790 shows it as a small hamlet clustered around a roughly rectangular green. High Green House has been the home of a long succession of notable local residents, including the coroner and hymn writer John Foster, who lived there from 1782 until 1822; Mr George Chambers of Newton Chambers, who is said to have rebuilt it in 1862; and Mr Harrison, the first headmaster of Ecclesfield Grammar School.

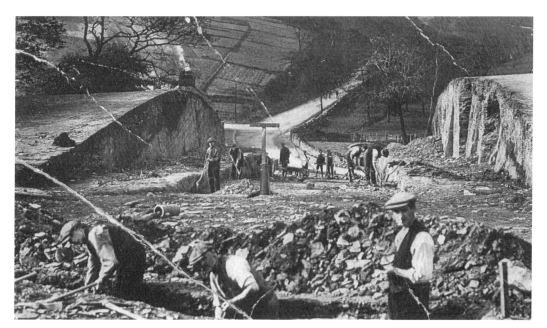

Hollow Gate. The view is from Greengate Lane looking towards Hollow Gate in the 1920s. In this period, several new roads were made in the area to improve communications for motorised traffic and to provide work for the unemployed. Prior to the rebuilding of this road through the rock outcrop, it had veered off to the left in front of Charlton Brook Farm before emerging again above the Bridge Inn.

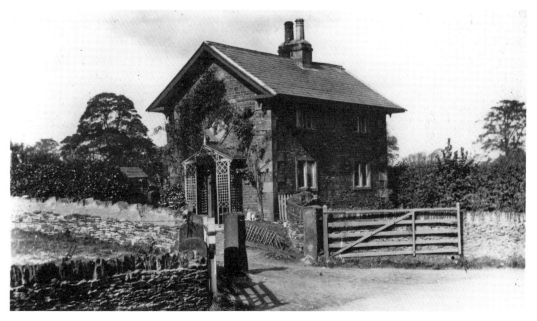

Greengate Lodge. Greengate Lodge at the entrance to Greengate Lane was erected as a toll bar cottage in 1837. Tolls were collected from users on behalf of the owners of Mortomley Hall, the owners of the private land through which the lane passed. In 1972, Mr Bernard Jordan, who was born there in 1888, recalled that when he was a boy his mother collected the one penny toll. The lodge was demolished in the 1930s when Greengate Lane was widened.

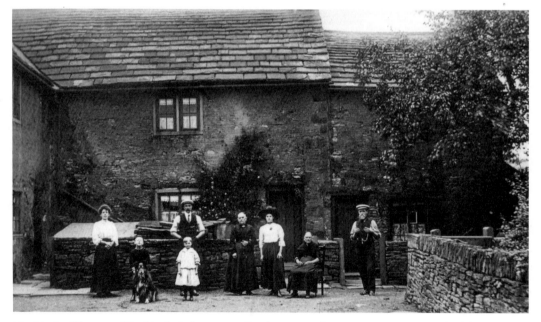

Angram Bank Farm. The 'Angram' in Angram Bank Farm is a name borrowed from fields surrounding the farm: *anger* meaning pasture and *angerum* meaning 'at the pasture'. This photograph was reputedly taken by a group of Americans who were retracing the footsteps of Charles Wesley and visited High Green sometime before the First World War. John Robert Gore stands in the doorway and the children are (from left to right) Norman, Sally, Harry and Edith Eleanora Gore.

Newbiggin. The name Newbiggin is from a medieval term 'newbigging', meaning a new building. A 'biggin' is also a word used to denote a hamlet. So Newbiggin was a small, medieval settlement set up much later than the main surrounding settlements. An important function of Newbiggin in the nineteenth century was the stabling of horses and ponies used by Newton Chambers in their collieries and around the ironworks at nearby Thorncliffe.

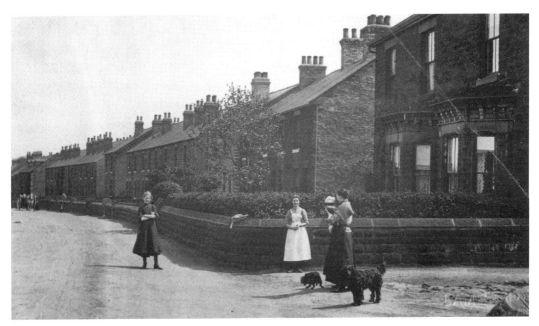

Warren Lane. The term warren was often used in medieval times for the part of a deer park that was set aside for breeding. Warren Lane follows the southern boundary of Tankersley Park, a medieval deer park. The settlement, shown here on the southern side of the lane, grew up in the nineteenth century to house workers in the collieries and at Thorncliffe Ironworks.

Staindrop Lodge was built in 1806 by George Newton, one of the founders of Newton Chambers' Thorncliffe Ironworks. It is named after Staindrop in County Durham, George Newton's birthplace. It was lived in by his descendants and was largely rebuilt in 1904 by his grandson, Thomas Chambers Newton. In the 1940s, it was taken over by the company for meetings and accommodating guests. It is now a restaurant and hotel.

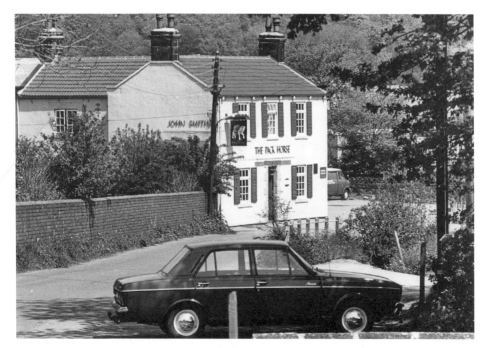

Pack Horse Inn, Mortomley. Most transport before the eighteenth century, even for carrying heavy goods, was by packhorse. One of the heaviest used routes was over the Pennines from the saltfields of Cheshire into South Yorkshire. En route horses had to be rested and grazed. And it was not only the horses that needed food, drink and rest. Carriers would put up at wayside inns. Hence the existence of the Packhorse Inn at Mortomley down Packhorse Lane.

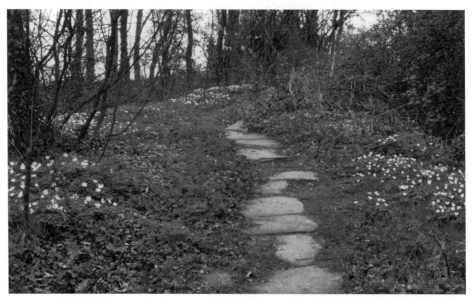

Packhorse track in Shroggs Wood. It is a wonder that goods ever got across the Pennines in the often torrential rain, high winds, thick fog, swirling mists and deep snow. The answer was to erect guide stoops and build underfoot 'causeys'. These were lines of flagstones about two feet wide. The causey shown here survives in Shroggs Wood behind Ecclesfield church.

Industry

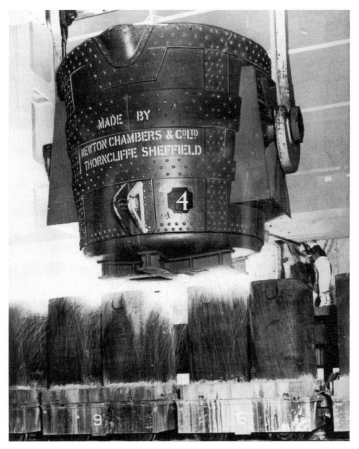

A 250-ton ladle and ingot moulds. Economic growth, population explosion and settlement expansion in Ecclesfield, Chapeltown and High Green were largely fuelled by metal working, principally iron, together with mining for ironstone and coal. These industries employed thousands of workers. The largest firm was Newton Chambers, which was engaged in ironstone and coal mining, iron production, engineering and chemical production over its nearly 200-year existence. Shown here is one of the firm's products that reached international markets.

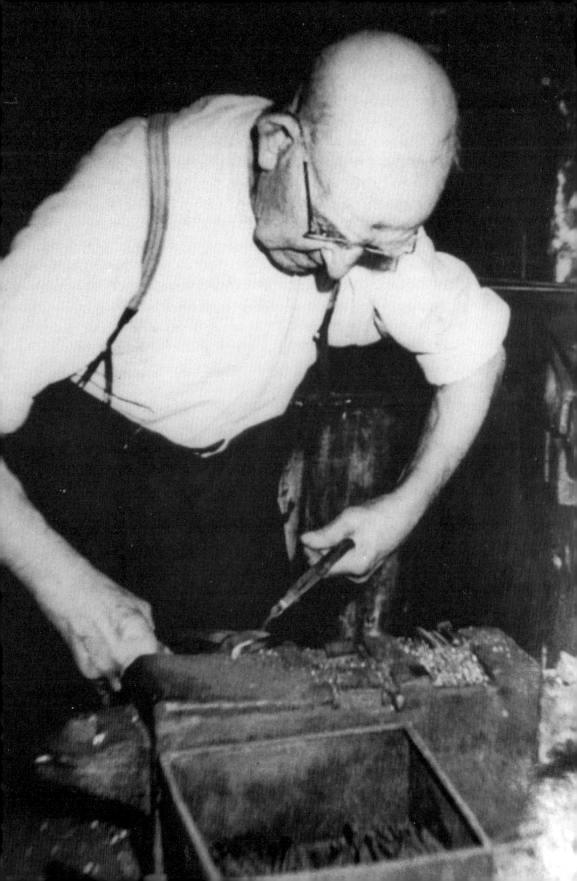

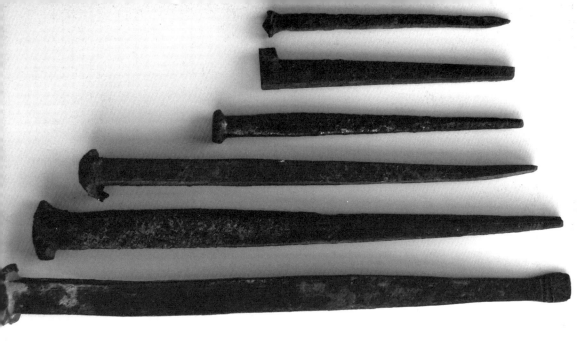

Above: Handmade nails. For at least 500 years there were nail makers in the area. In 1707, forty nailmaking workshops were recorded in the village of Ecclesfield. The trade continued to grow in the eighteenth century but in the nineteenth century went into steep decline. The process of nail making was simple. Rod iron was heated in a fire and then cut into lengths on an anvil. These were then placed in a hole in the anvil and hit with a hammer to form a head. There were numerous variations to make different kinds of nails.

Opposite: John Thomas Ridge, gimlet maker. Gimlet making in Ecclesfield was monopolised largely by one family, the Ridges. In the 1881 census there were eight members of the Ridge family, living in three different households in the village core, who were gimlet makers. The family trade went on into the twentieth century. John Thomas Ridge, pictured here, was born in 1879 but did not retire from the trade until the 1970s, when he was in his nineties. When he first started making gimlets he said he got 'tuppence a gross'.

Henry Greaves, file manufacturer. By the beginning of the nineteenth century, nailmaking in Ecclesfield was in sharp decline because machine-made nails were on the market. Nailmaking smithies were converted into file workshops and domestic file-cutting grew rapidly. In the second half of the nineteenth century, hand file-cutters became the outworkers of factories that made hand-cut and machine-made files. Increasingly, hand craftsmen were organised into small works. Henry Greaves, pictured here, set up his own small works, St Michael's Works, at High Greave, Ecclesfield.

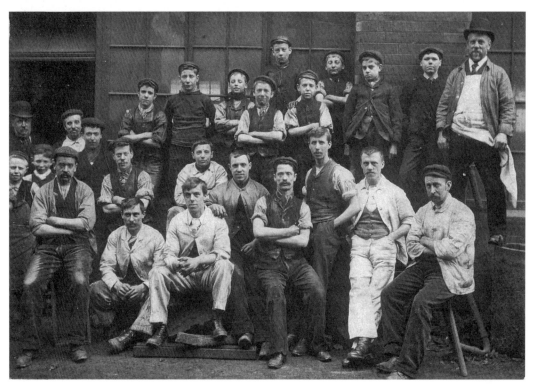

Henry Greaves' workforce. Assembled for a team photograph are the men and boys employed by Henry Greaves at St Michael's Works. Henry Greaves stands at the back on the right. The hand cutting of files was very laborious. The worker sat with his knees on either side of his 'stiddy' (anvil). Resting on the stiddy was a block of lead on which the blank file was set when cutting. The relatively soft lead prevented any damage to the cut surface when the file was cut on the reverse side. The filemaker's disease was lead poisoning.

Oliver Cottages, Ecclesfield. Variously known as Wragg Wheel, Oliver Wheel and Oliver Cottages, this water-powered industrial site was first recorded in 1510 in the will of a scythe maker. It was later occupied by a cutler and then from 1767 until 1810 it operated as a water-powered paper mill. For at least a century, from the 1820s it was a fork-making works. During this phase, the site also became a residential community with as many as twelve households, with some of the cottages being converted from industrial premises.

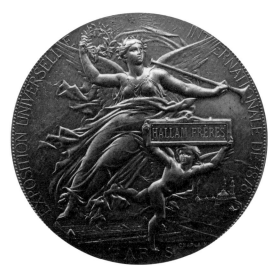

Gold medal presented to Hallam Brothers of Ecclesfield. Hallam Brothers owned the mill at Butterthwaite Dam from 1859 until the 1890s. It was known as the Butterthwaite Steel Wire and Pin Works. Their principal products were hackle pins (sharp steel wires for combing hemp, cotton, wool, jute and linen for the textile industry), fish hooks, sewing and machine needles, knitting needles, hair pins, meat skewers, bicycle spokes and umbrella frames. They were awarded gold medals at trade exhibitions in Paris and Melbourne.

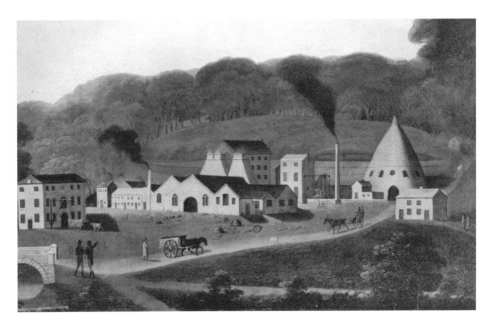

Thorncliffe Ironworks, *c.* 1800. In 1793, George Newton, Thomas Chambers and Henry Longden, signed a twenty-one-year lease from Earl Fitzwilliam for land at Thorncliffe. The purpose was to build an ironworks and to mine coal and ironstone. The site of the blast furnace was beside the Blackburn Brook and the coal and ironstone were to be exploited beneath the wooded valley slopes. Thus was born the firm of Newton Chambers, which operated for the next 180 years.

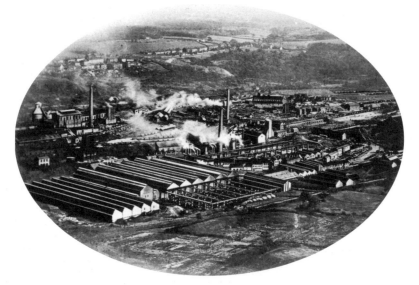

Thorncliffe Ironworks in the mid-twentieth century. A century and a half after its foundation, the Thorncliffe works dominated the whole of the valley of the Blackburn Brook at Thorncliffe. The firm employed local people in a bewildering variety of jobs. They operated, at one time or another, collieries, ironstone pits, limestone quarries, coke ovens, blast furnaces, foundries, excavator plants, chemical works and bottling plants. This complex industrial enterprise was supported by wide-ranging training and welfare facilities, workers' housing and cultural and sporting opportunities.

Blast Furnace, Thorncliffe Ironworks. The first blast furnace started work in April 1795, followed by another one a year later. Together these blast furnaces were capable of producing 1,800 tons of pig iron a year. They were replaced in 1873/74 by two new furnaces that produced 31,000 tons of pig iron a year. These two furnaces, together with a third built in 1913, were eventually replaced by a mechanised furnace in 1927, which could produce 50,000 tons of iron a year. The last pig iron was produced in 1943.

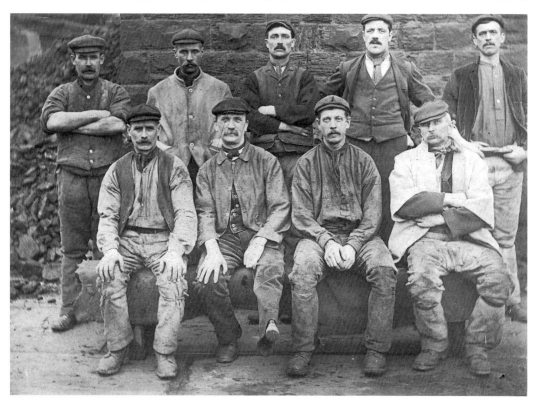

Blast furnace workmen, 1906. David Hunt (front row, second from the left) was the hoist man who worked the hoist that elevated the ore, coke and limestone into the top of the furnace. William Windle (back row, second from the right) acted as liaison between the blast furnace manager and the fillers. All the other men were fillers who barrowed the raw materials to the furnace. They all worked twelve-hour shifts with a double shift on alternate Sundays.

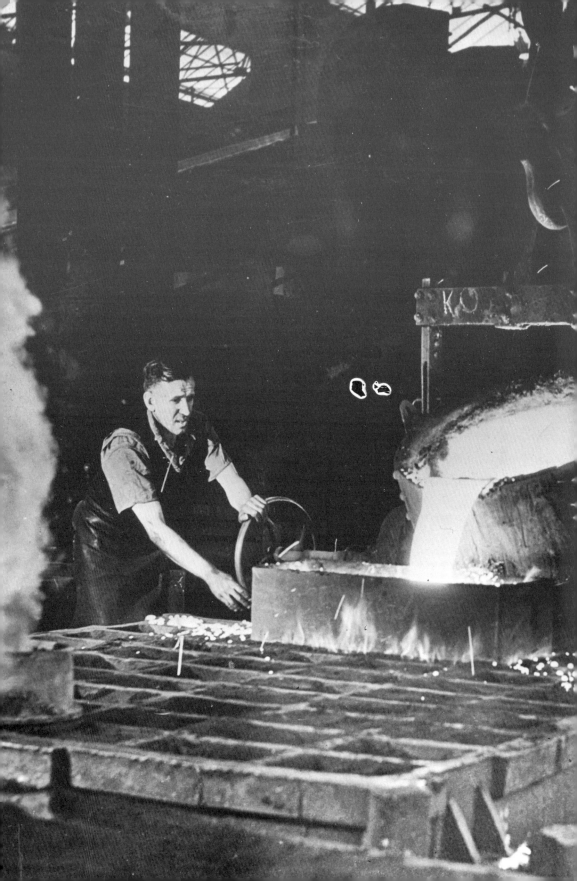

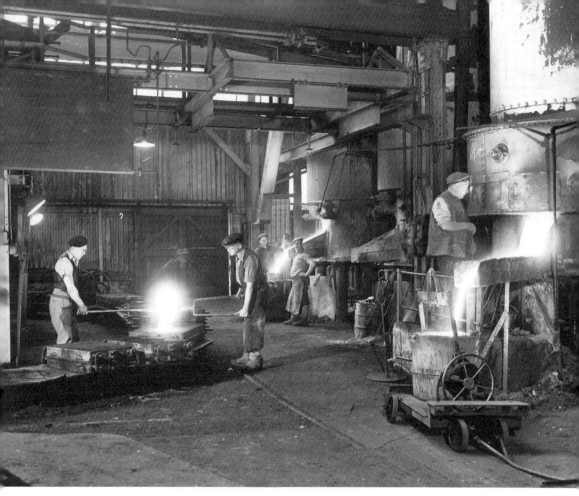

Above: The light castings department, Newton Chambers. This is another evocative scene captured by Walter Nurnberg. As in most of his photographs, here we see human effort, tenacity and skill given equal place with the technology. He believed that productive work was essential to human dignity. On his first visit to a new industrial site he did not take his camera; he simply watched and pondered. Then he composed his pictures with immense care, using natural sunlight and his own powerful lamps.

Opposite: Harry Yale in the heavy castings department, Newton Chambers. This dramatic photograph of Harry Yale pouring molten iron in the heavy castings department at Newton Chambers' Thorncliffe Ironworks was taken by the German-born photographer Walter Nurnberg (1907–1991). After having carved out a career in advertising photography in the 1930s, Nurnberg served in the British Army during the Second World War and afterwards he became the official photographic recorder of a substantial number of great British manufacturing enterprises.

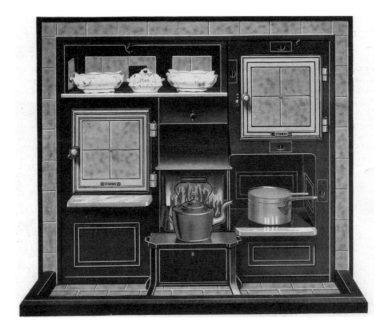

Thorncliffe patent cooking range. In 1860, Newton Chambers acquired Chapel Furnace, later the site of the Izal factory. This foundry was to produce the famous Thorncliffe patent cooking range. The one shown here was the 'Super Master' combination grate. It was fitted with tiled oven doors and hearth and had ovens that 'could be quickly heated and high enough to avoid stooping'. This range was said to be 'capable of cooking for a household of twenty persons'!

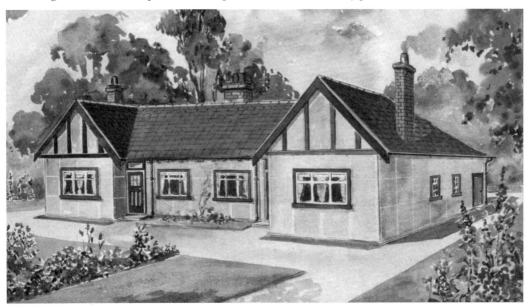

Thorncliffe bungalows. After the First World War, with a shortage of housing, Newton Chambers began the production of cast-iron houses. The walls were built from cast-iron plates and covered on the outside with a coating of concrete. Experimental houses were built in Mortomley Close, which are still in existence today. Two estates were built in Derby. Shown here is the Thorncliffe bungalow, which was offered at the price of £285 if built within 10 miles of the works.

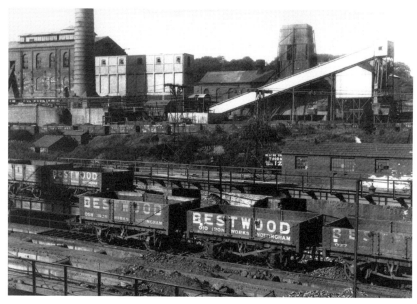

Thorncliffe Ironworks from the blast furnace. This shot was taken by Stanley Ellam from the top of the blast furnace in 1933. Mr Ellam started work in the fitting shop in 1927, at the age of fourteen. He then became a draughtsman and worked for the firm until 1943. What is clear from the photograph is the internal network of railway lines by which raw materials such as coal, iron ore and limestone were assembled, and partly finished and finished products were transported around and off the site.

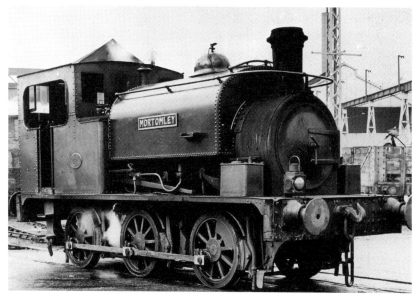

'Mortomley' locomotive at Thorncliffe Ironworks. Pictured here is just one of the locomotives used to pull and shunt raw materials and part-finished and finished products around the works. Each had a local name: Mortomley, Tankersley, Hoyland, for example. This locomotive was built by Hudswell, Clarke & Co. Ltd of Leeds in 1891. It was purchased by Newton Chambers in 1909 and worked for nearly fifty years until it was sold for scrap in 1955.

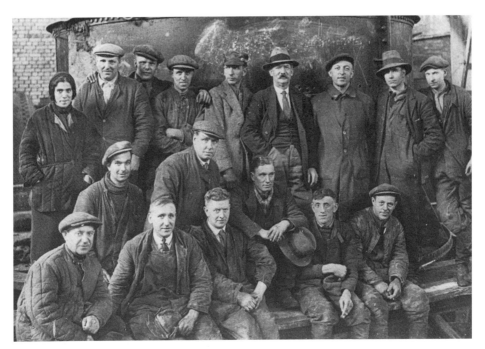

Thorncliffe workers in the Soviet Union in 1932. In 1932, a small party of Newton Chambers employees made the 1,700-mile overland journey to Bobriki near Moscow to erect a steelworks gas plant. They then installed a semi-water gas plant, a pig iron casting machine and ore/coke transfer cars at a steelworks near Magnitogorsk in the Urals. Here the team pose for a photograph with their Russian interpreter, Nina, in the back row on the extreme left.

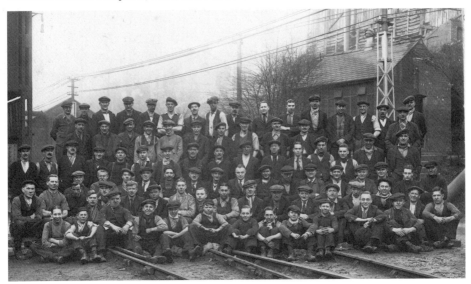

Moulders at Thorncliffe Ironworks in 1934. This group of moulders, almost all flat-capped, were photographed during a dinner break. They include, in the front row, some very young boys serving their apprenticeships. The caps were the only protection against hot metal. Hot liquid metal had to be carried from the cupola (furnace) to the moulds made in sand and then carefully poured into the mould. When cooled, the castings had to be 'fettled' (the mould marks and sand removed).

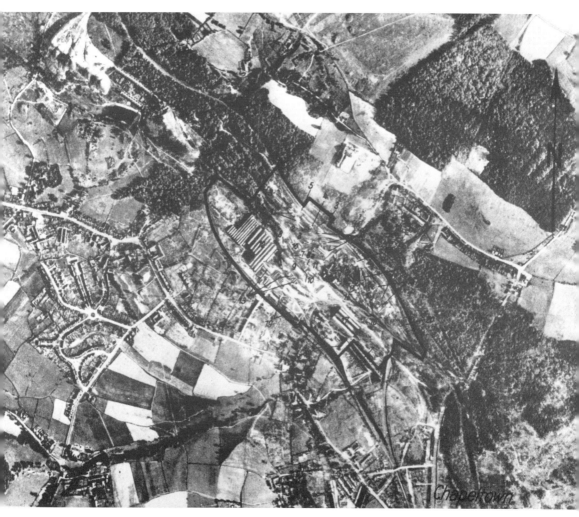

Luftwaffe map of Thorncliffe Ironworks. This aerial photograph of the Chapeltown area with the boundaries of Thorncliffe Ironworks boldly marked was found in the map room of a German air force station at the end of the Second World War. Each department is numbered and identified in a key beneath the photograph (not shown here). It is a bit unnerving seeing in German beside Burncross Road 'Nach Sheffield mitte etwa 9km luftlinie' (central Sheffield about 9 km as the crow flies)!

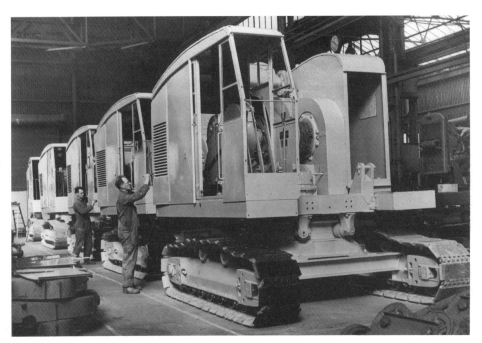

NCK Excavator Factory, Warren Lane. Newton Chambers began manufacturing excavators in 1935 in association with the American firm Harnischfeger & Pawling, hence the original NCH designation. A new excavator factory was built but before it was finished war broke out and tanks were made instead of excavators. After the war an agreement was made with another American firm, Koehring & Co., and a new range of excavators was produced with the designation NCK. In 1958, the excavator firm Ransomes & Rapier was bought out.

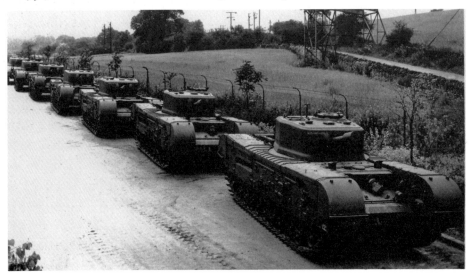

Churchill tanks. Newly made Churchill tanks line up in the roadway on Warren Lane ready for testing. During the Second World War, Newton Chambers manufactured 1,160 tanks in the excavator factory on Warren Lane. The location of the tank factory was thankfully unknown to the Germans and was not marked on their aerial photograph. In the background can be seen the aerial ropeway carrying coal from Rockingham Colliery to Smithy Wood Coking Plant.

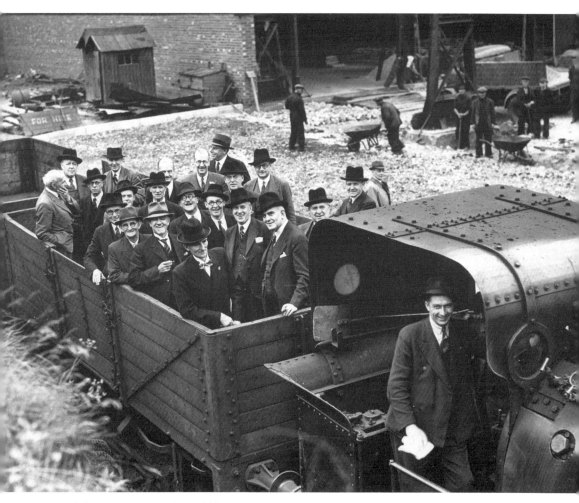

Yorkshire MPs visiting Thorncliffe Ironworks. Newton Chambers were always keen to show off their works to important visitors, not least to show their devotion to war work during the two World Wars. And what better way to transport these Yorkshire MPs round the works in 1943 than one of the works' locomotives. Social distinctions are very apparent, with the workers in the background all wearing flat caps while the MPs sport three-piece suits and hats.

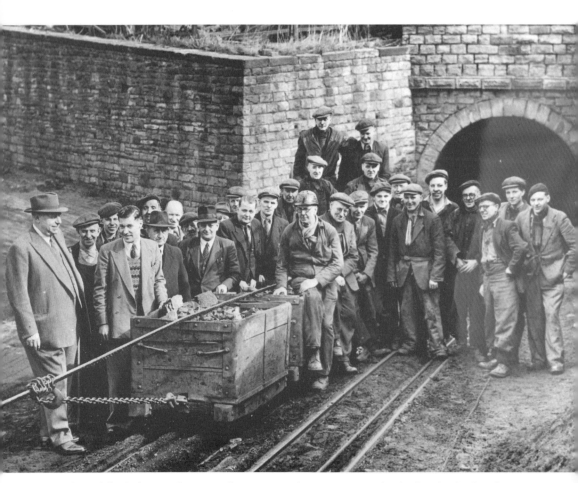

Thorncliffe drift pit. After around a century of continuous work, the last haul of coal was drawn from the drift pit at Thorncliffe on 2 April 1955. By this time, of course, the company's collieries had all been nationalised. The company chairman, Sir Harold West, is on the extreme left. The helmeted figure sitting on the tub is seventy-two-year-old George North, who was an underground rope signalman for sixty years.

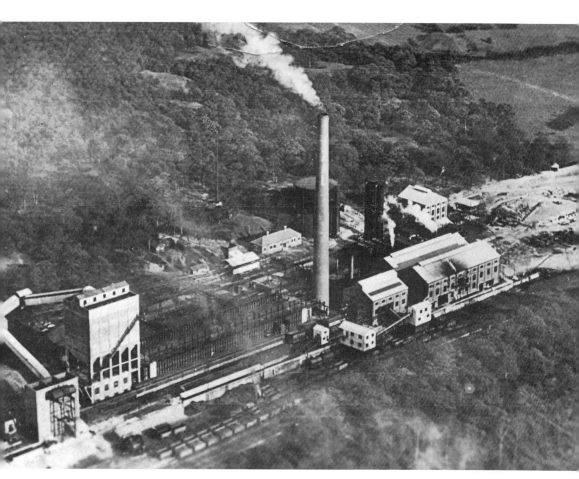

Smithy Wood colliery and coke ovens. In the 1890s, Newton Chambers of Thorncliffe Ironworks sank Smithy Wood Colliery and developed coke making in the lower part of the woodland site. In 1929, fifty-nine coke ovens of the most modern type were installed by Woodall-Duckham. The colliery closed in 1972 and the coking plant closed in the mid-1980s, leaving a scarred, derelict area where a large part of the ancient wood had once clothed the landscape. This is the site now partly occupied by the Smithy Wood Office & Business Park.

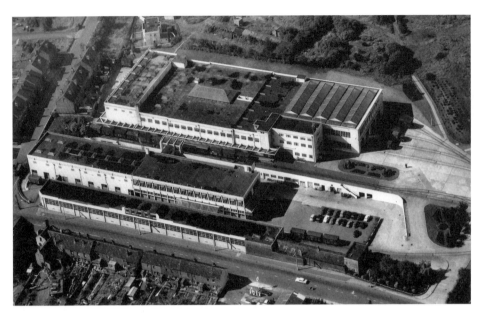

The Izal Factory, 1963. The trade name Izal was registered by Newton Chambers in 1893. The germicidal oil was a by-product of coke making from coal for the blast furnaces at Thorncliffe Ironworks. It became world-famous in the fight against disease and besides the famous Izal toilet paper, 136 other Izal products were marketed. Work began on the factory in the 1930s but was interrupted by the war. Work resumed in 1947 and it was finished in 1950.

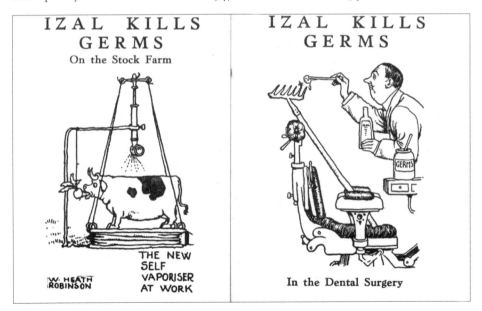

Heath Robinson postcards. In 1924 and 1932 Newton Chambers engaged the comic artist William Heath Robinson to visit the works and to make drawings to advertise the Izal range of products. He produced two booklets, *Thorncliffe Visited* and *Heath Robinson Sees Izal Made*. Subsequently, the firm used a range of his drawings on Izal toilet paper. Newton Chambers also produced a series of Heath Robinson postcards showing the wide variety of uses of Izal disinfectant. Shown here are the postcards demonstrating its use on the farm and in the dentist's surgery!

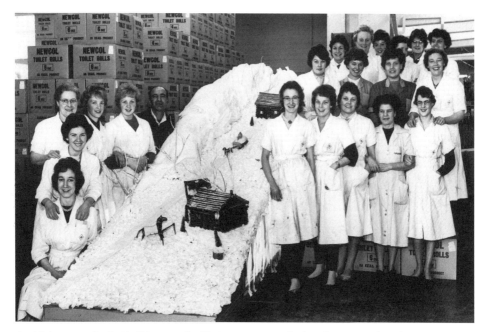

An Alpine scene in the Izal Factory. As Christmas approached each year, workers from each room in the Izal factory entered a competition to have the best festively decorated area. Subjects were very varied and included large figures of Father Christmas, Santa's reindeers, the manger in the stable, Christmas fireside scenes and snow-covered churches. In this entry from 1961 we are in a snow-covered Alpine valley with a horse-drawn sleigh descending the slope.

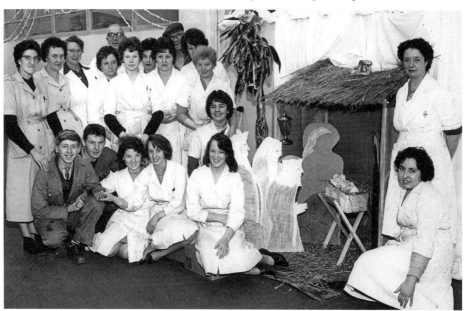

Another festive scene in the Izal Factory. Everything in these Christmas scenes was made out of spare tissue, cardboard and other waste materials. Members of the managerial staff adjudicated but there was no first prize, just the prestige of winning. In this scene, again from 1961, we see Mary and Jesus and the Three Wise Men in the stable.

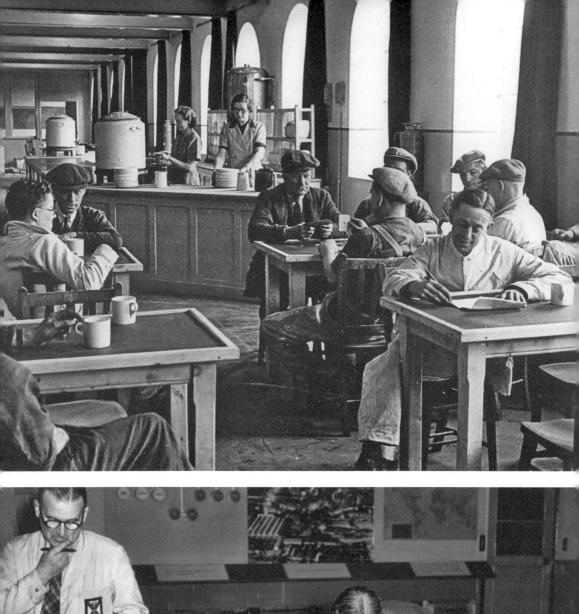
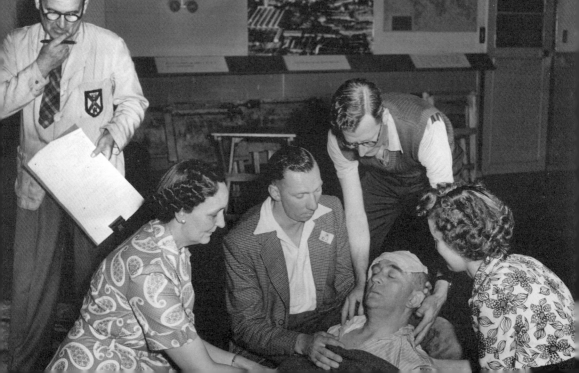

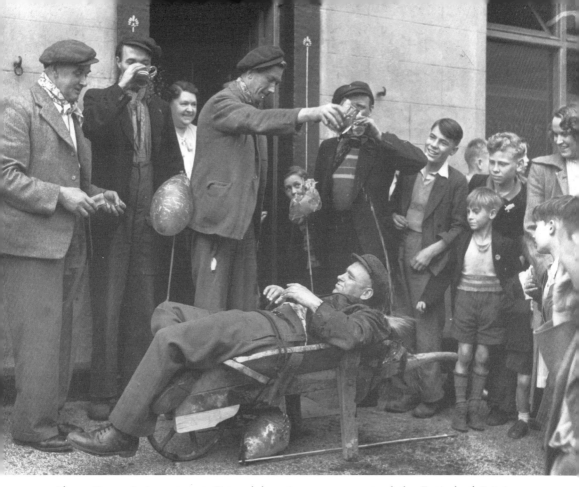

Above: 'Barrowing' enactment. Pictured here in 1951, as part of the Festival of Britain celebrations, is an enactment of the traditional way of dealing with a lazy worker who failed to turn up for work without reason: his workmates would black his face and tie him into a wheelbarrow. At every pond and stream they would duck him and then call at local pubs where they would pour their beer dregs all over him. Then they tipped him in the road after he had promised to work regularly in the future.

Opposite above: Works canteen, Newton Chambers. Except for a short period in the 1860s and 1870s when the company was at loggerheads with its coalmining employees, which led to an eighteen-month lock-out and the employment of 'blackleg' labour, Newton Chambers were regarded by their staff as caring employers who provided a wide range of social and cultural activities and excellent rest and recuperation facilities. The walls of the works canteen were decorated with paintings by a well-known artist.

Opposite below: First aid test, Newton Chambers. In such a varied working environment, which included heavy castings and light castings departments with overhead cranes, an internal rail network, overhead ropeways and coke ovens, accidents were always likely to happen. For this reason, staff underwent short courses in first aid. Thankfully in this first aid test, the patient looks quite comfortable!

Above: Festival of Britain celebrations. The 'barrowing' enactment above was part of a series of events celebrating 'Games & Customs of 100 Years Ago', which included country dancing, maypole dancing and 'old time' cricket. But there were also more modern amusements including an outdoor circus with tightrope walkers and trick cyclists, a model aircraft flying display and, as shown here, fairground-style amusements for the children.

Opposite above: Thorncliffe Foremen's Association dinner. Staff at Newton Chambers were always organising outings for themselves and their families. These included fishing trips, days at the seaside and trips to Sherwood Forest. Even for annual dinners, distance was no object. Shown here with their wives are members of the Foremen's Association at their annual dinner at the Marquis of Granby Hotel at Bamford in north Derbyshire.

Opposite below: Girls' pre-entry course, Thorncliffe Works, 1948. From 1943, young female typists were trained in the Works College. After a pre-entry fortnight when they were given talks and shown around all the departments, the girls were attached to an office but continued to spend mornings or afternoons at the college. In charge was Miss Berry, who was stickler for detail. She impressed upon her charges that their work and appearance reflected on the company. Her first words on entering the classroom were 'Open the windows! Take off your cardigans!'

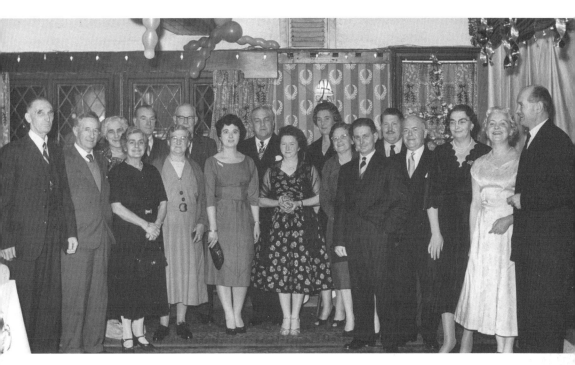

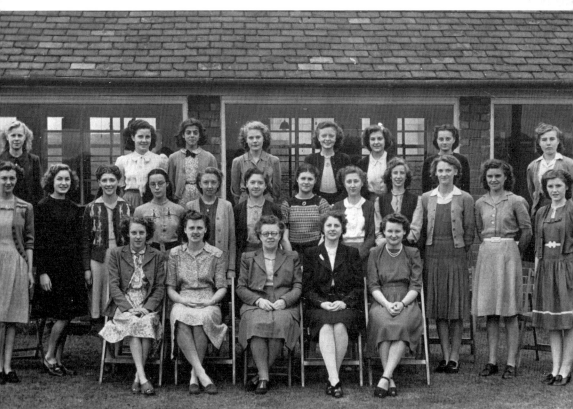

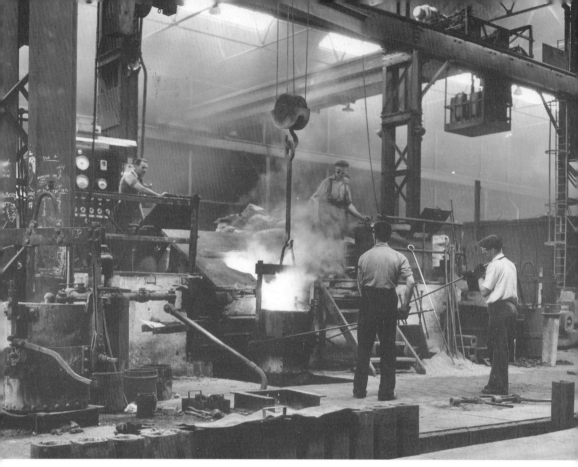

Above: The melting shop, Hall & Pickles. Hall & Pickles were originally a firm of metal merchants and iron stockholders from Manchester. In 1931, they built their Hydra Steel Works on greenfield land on Nether Lane in Ecclesfield. Here they installed an electric furnace, a forge and a wire mill. They produced heat-resistant stainless steels, electrical resistance wire and high-quality engineers' cutting tools. The works has now gone and the site is a business park.

Opposite above: Fireplace made by W. Green & Co., Ecclesfield. William Green took over the Green family foundry on the site of the present Morrisons superstore in 1862 and named it the Norfolk Foundry. Green's manufactured all kinds of stove grates and kitchen ranges. During both World Wars, Green's supplied catering equipment to all three of the armed forces. The photograph shows a kitchen range in the manager's house at Abbeydale Industrial Hamlet, Sheffield.

Opposite below: Charlton Brook foundry, founded by Jabez Stanley, made cast-iron manhole covers and gulley grates, and exported them to most parts of the world. Between 1896 and 1944, it was owned by George Harvey, then by Tom Oxley and later Michael Oxley. The foundry closed around 1990 and the site is now covered by housing.

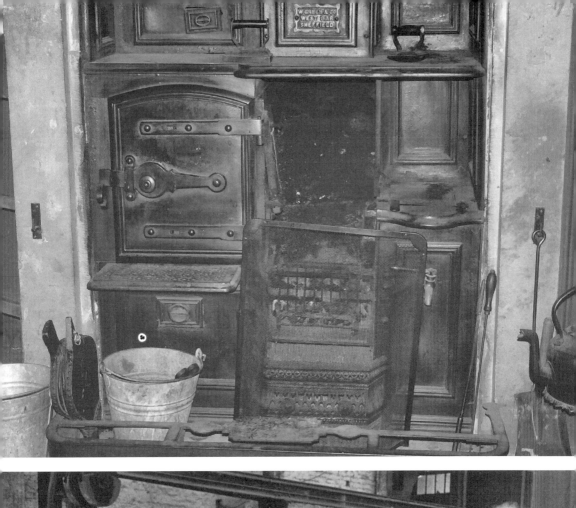

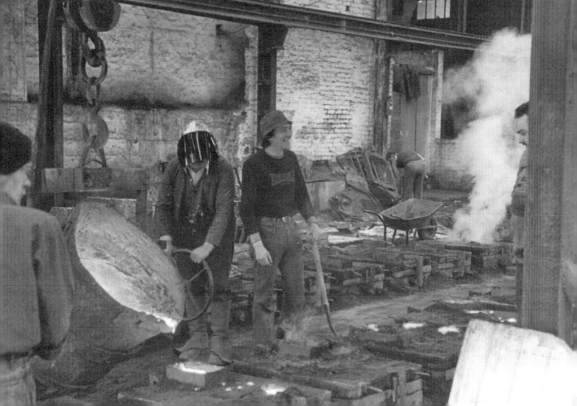

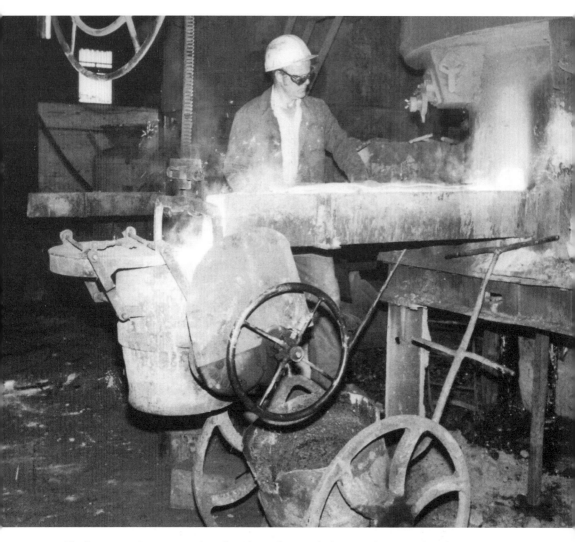

The last cast at Parramore's foundry. Shown here is the last cast being produced at Parramore's foundry, the Caledonian Works, next to Smith Street in Chapeltown in 1981. The foundry was founded by Fred Parramore in 1904. The firm specialised in light castings and supplied many famous names in British industry.

Expanding Communities

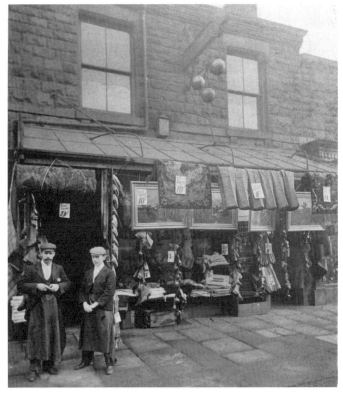

Pawnshop, Station Road, Chapeltown. As the population grew (the population of Ecclesfield parish, which included Ecclesfield, Chapeltown, High Green and Grenoside, grew from just over 5,000 in 1801 to 22,000 in 1901), the settlement expanded and there was a large growth in commercial enterprises to serve the local population. Here is Whitaker's pawnshop on Station Road, Chapeltown. Among the many items on display are carpets, rugs, paintings, boots, shoes and caps. The rolled-up carpet over the doorway is marked 9d.

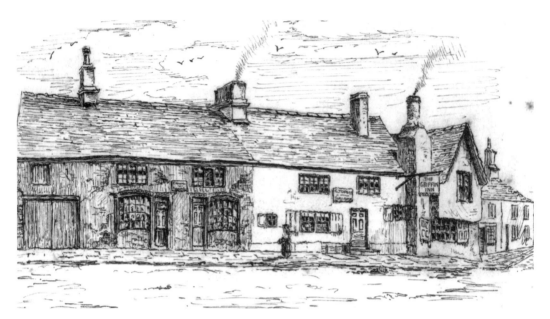

The Griffin Inn, Stocks Hill, Ecclesfield. As already pointed out, Stocks Hill formed a busy open space that contained the village stocks. Its three sides contained a variety of commercial premises and workshops, including a butcher's and a grocer's and three public houses: The White Bear, The Tankard (later The Stocks) and The Griffin Inn. This drawing from 1887 by W. G. Fox shows The Griffin Inn. The landlord at that time was Matthew Stringer.

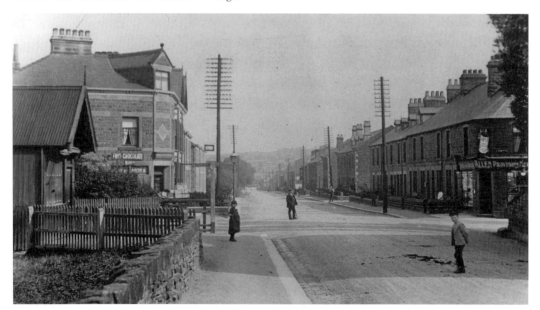

The Common, Ecclesfield. As its name suggests, the Common was originally a large open space on which commoners' sheep, cattle and horses grazed. It also contained the village pinfold, where stray animals were pounded and not released until the owner paid a fine. With the expansion of industrial employment during the nineteenth century, it became a mixed area of terrace houses and industrial premises dotted with shops. The one in the right foreground is Allen's grocery shop and the one opposite is advertising Fry's chocolate and Virol.

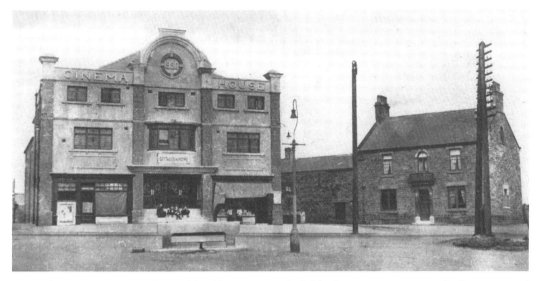

The Cinema House and Arundel Public House, Ecclesfield. The Cinema House was built in 1920 and was closed and demolished in the 1970s. The main entrance is flanked by two shops, one of which was a sweet shop handily located so that cinemagoers could buy their chocolates and toffees and crinkle their wrappings during the performance! The Arundel is named after a minor title of the Duke of Norfolk, a major local landowner.

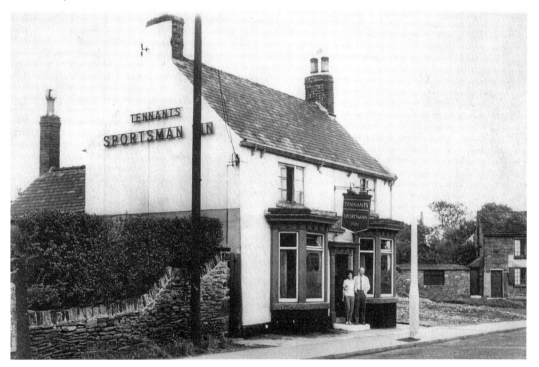

The Sportsman Inn, Ecclesfield. The first reference to this public house, which stood on High Street in Ecclesfield, was in 1833. The landlord at that time was William Foster, who like many in that occupation in the past had dual occupations. He was a victualler and a file manufacturer. Ecclesfield Library was built on the site after it closed.

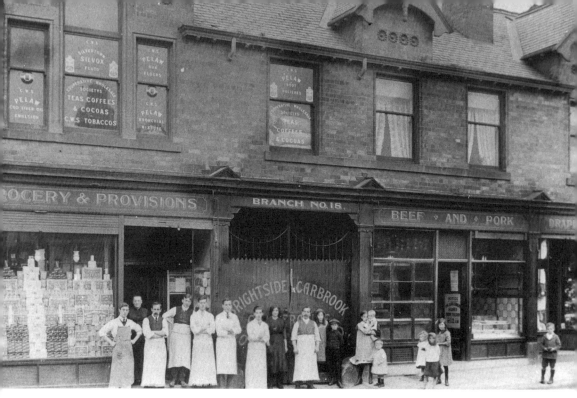

Above: Brightside & Carbrook Co-operative stores, High Street, Ecclesfield. Branch No. 18 of Brightside & Carbrook Co-operative Society dominated Ecclesfield High Street in the past. It had a grocery and provisions department, beef and pork butchers, and drapery and boot and shoe departments. The location of Ecclesfield, Chapeltown and High Green between two much larger urban areas is reflected in the fact that Ecclesfield's Co-op was a branch of one of the two Sheffield co-operative societies, while Chapeltown and High Green's were branches of the Barnsley British Co-operative Society.

Opposite above: Ecclesfield Great Central Railway Station. The station was opened in November 1854 on the line from Sheffield up the Blackburn valley to Thorncliffe, Westwood, Pilley and Worsbrough en route to Barnsley. The line through the Blackburn valley was originally a single track railway but was made into a double track in 1875. A new station was opened in 1876. The stationmaster in the 1930s was Thomas Stanley Pleasence, the father of the actor Donald Pleasence. The passenger service and the station closed on 7 December 1953.

Opposite below: Gibsons' shops, Chapeltown, *c.* 1860. This is one of the earliest photographs in our collection. The brothers Thomas and John Gibson were described in White's Directory for 1856 as 'grocers, drapers and druggists'. John Gibson was the grocer/draper and Thomas Gibson's shop was a post office and drug store. The premises had originally been the 'truck shop' for Newton Chambers. Until 1831, workers could be paid part of their wages in tokens that could only be exchanged for goods at a firm's truck shop.

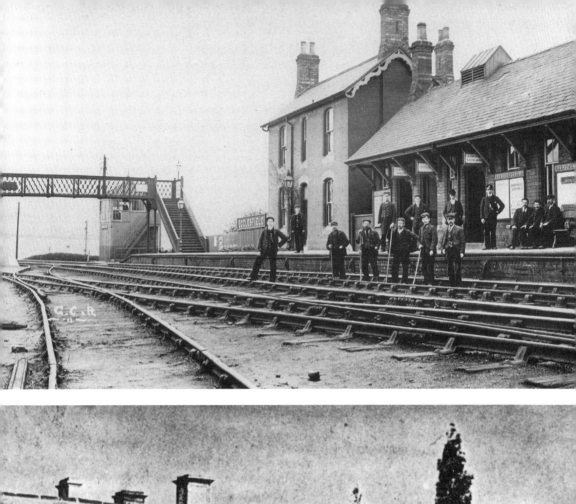

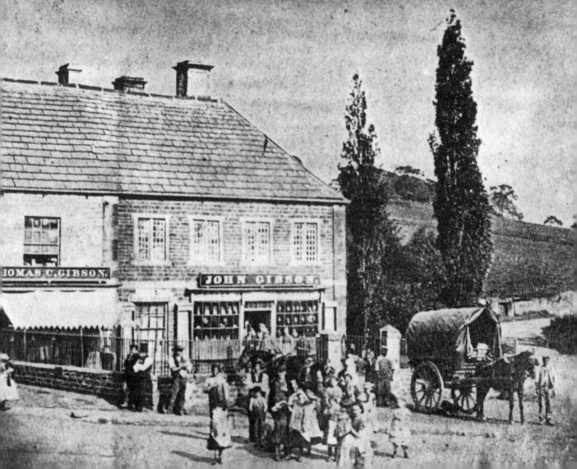

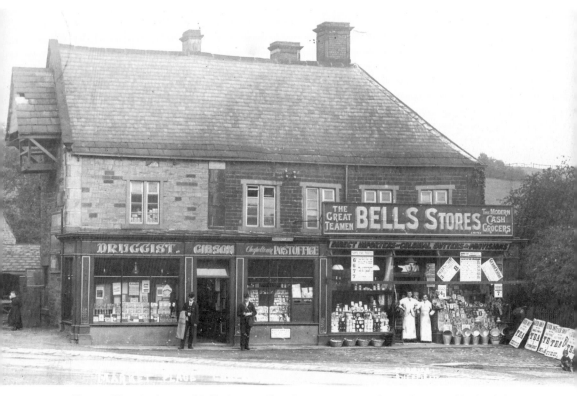

Above: Gibson's shop and Bells Stores, Chapeltown, *c.* 1900. This is the same block of shops as above but it is forty years later, and although the left-hand part of the block is still Gibson's druggist's and post office (with two postmen standing outside), the right-hand part of the block has changed hands. This is now Bells Stores, the owners of which announce themselves as 'THE GREAT TEA MEN' and 'THE MODERN CASH GROCERS'.

Opposite above: The Crossroads, Chapeltown. The initial reason for the growth of a settlement at Chapeltown was its crossroads location with, to the left, the road leading to Huddersfield, to the right leading to Rotherham, directly in front along Station Road in the direction of Barnsley, and behind the camera leading to Sheffield. The left-hand side of the photograph is dominated by the Waggon & Horses public house, while on the right-hand side stands Newton Chambers' former truck shop. This was occupied by Melias grocery shop when this picture was taken in the 1920s.

Opposite below: Shops in the Market Place, Chapeltown. For more than two centuries, Chapeltown has been an important retail and commercial centre for the surrounding area with its shops, open-air market, banks and public houses. This photograph, taken in the early 1960s, between the railway bridge and the Waggon & Horses, can be seen Charles' dress fabrics, C. R. Storr & Co.'s boot and shoe repairer's and Hobson's butcher's shop.

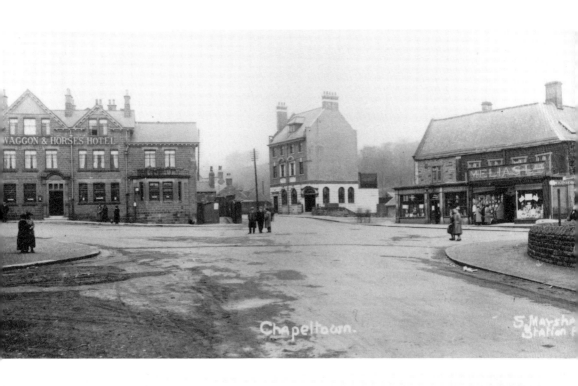

Chapeltown.

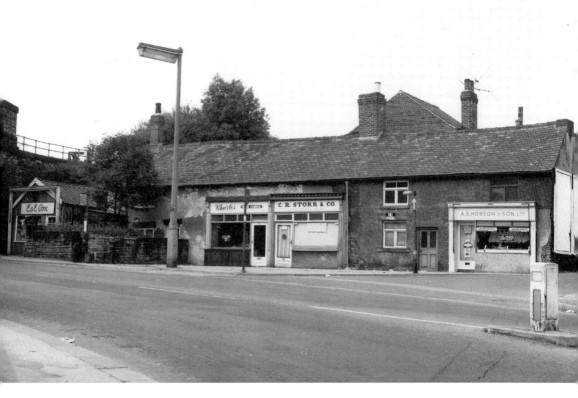

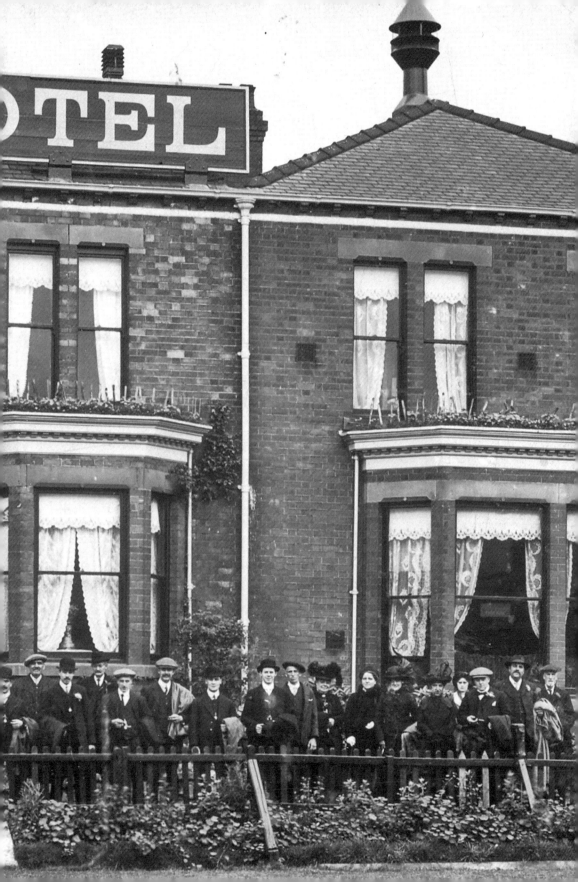

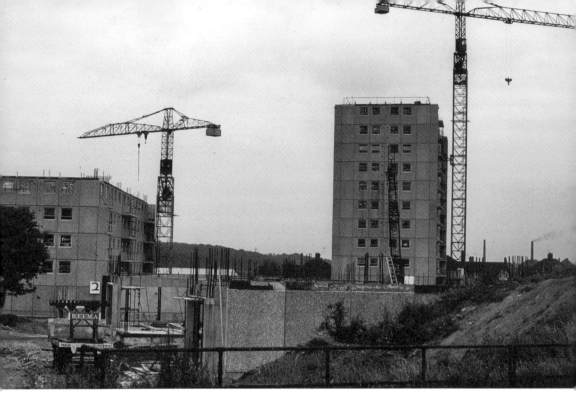

Above: High-rise flats, Chapeltown. These multi-storey residences are shown here under construction in 1965. Chapeltown was then administered by Wortley Rural District Council (RDC), which was the first RDC to embark on a high-rise scheme. When completed in 1966, it provided nearly 200 flats, thirty-eight maisonettes and a community centre. The three blocks of high-rise flats have now been demolished.

Opposite above: Chapeltown Working Men's Club. The club opened in 1901 at a cost of £2,500. According to White's Directory of 1902, it comprised 'conversation, billiard, smoking and games rooms'. It also contained baths. In 1902, it had 420 members and the secretary was George William Civil.

Opposite below: Midland Bank, Station Road, Chapeltown. This is a view from the crossroads looking along Station Road with the Waggon & Horses public house on the left. The three-storey building on the right is the Midland Bank, including the living quarters of the bank manager and his family. Shirley Carter (née Hammond), the bank manager's daughter, born in 1930, remembers watching the Whitsuntide procession from her third-storey bedroom window and lying in bed and hearing the miners going to and from their morning shift in their noisy clogs.

Previous page: Midland Hotel, Chapeltown. This public house, later called The Carousel and now The Escape, acquired its old name because of its location near to the Midland Railway station in Chapeltown. The large group of customers assembled in front of the hotel are gathering prior to a day out at the York races in 1914. On the doorstep can be seen the landlord, Scholey Almond, flanked on the left by his daughter Cissie in the white dress, and on the right by his son Leslie.

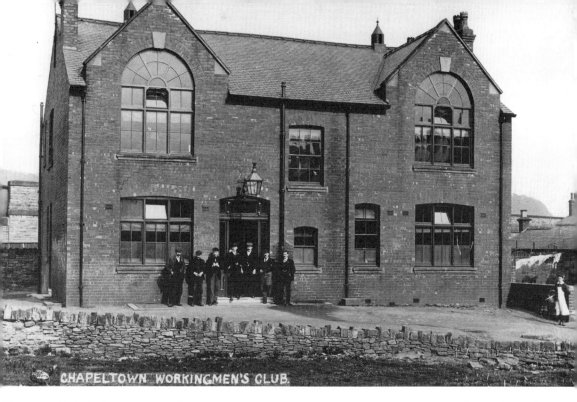

CHAPELTOWN WORKINGMEN'S CLUB.

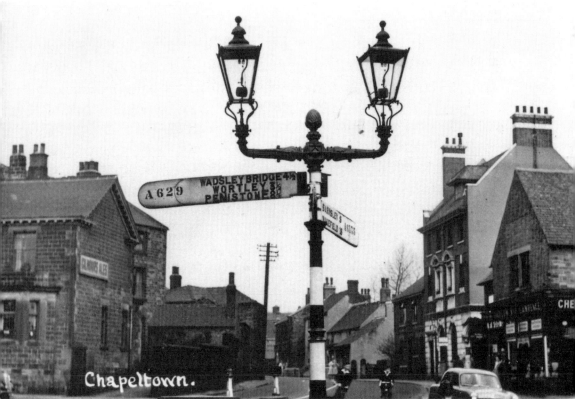

Chapeltown.

Station Road, Chapeltown. Dating from the early 1900s, this view shows the Primitive Methodist Chapel wedged between the Commercial Hotel and a row of shops, including W. Brock's watch and clock repairs and jewellery store. As was usual at this time, the photographer has attracted a large group of 'extras', but three small children completely ignore what is going on, preferring to look intently at the goods in Brock's window.

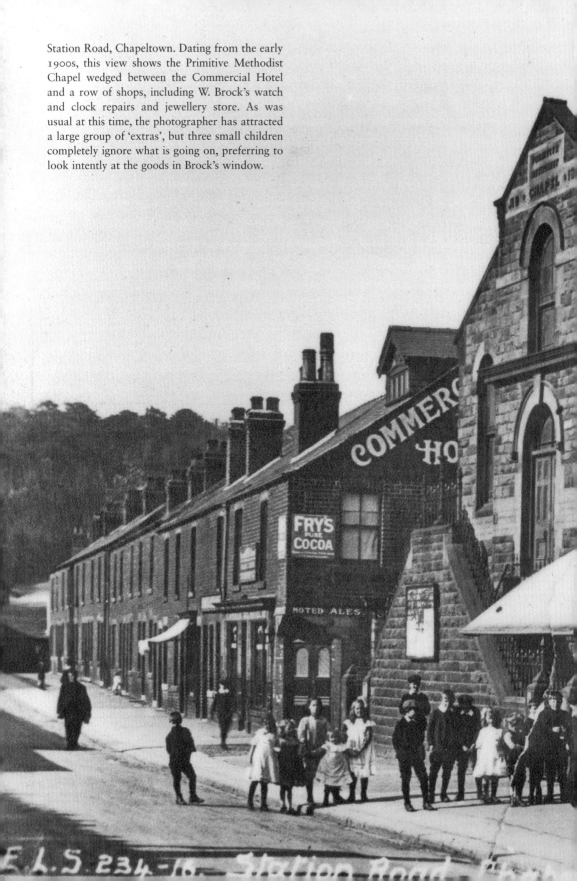

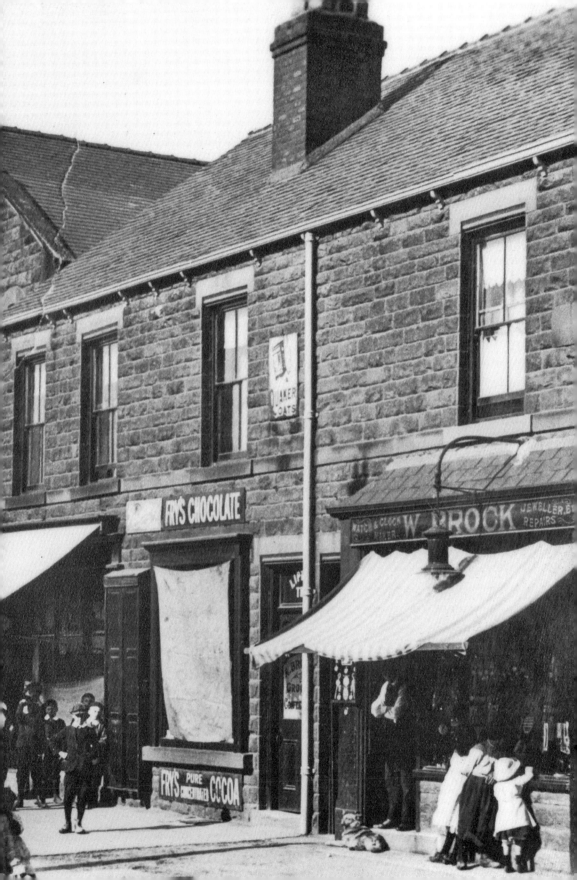

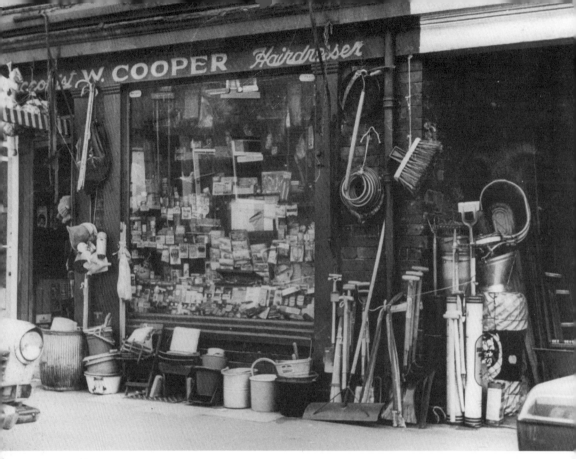

Above: 'Chinny' Cooper's shop, Station Road, Chapeltown. Wilf 'Chinny' Cooper's shop was a local institution. Not only could you get a haircut or a shave but you could buy almost anything, including working boots, leather laces, metal buckets and 'snap' tins, shovels and spades and wash tubs to name but a few. And everything on sale was on display: outside the shop, in the window and inside the shop, including on the stairs.

Opposite above: Whitefield cottages and Sussex Road, Chapeltown. The old, whitewashed Whitefield Cottages, now gone, obviously predate the other terraced houses on Sussex Road. The road name is derived from a minor title (the Earl of Sussex) of the local landowner, the Duke of Norfolk. Sussex Road leads to Arundel Road, the Earl of Arundel being another minor title of the dukes of Norfolk. The building at the far end of the road was the ticket office of Chapeltown's Midland Railway station.

Opposite below: Belmont Avenue, Chapeltown. This short road off Lound Side contains a series of stone-faced, short terraces. It was laid out on the southern edge of the grounds of Belmont House, which was the home of Arthur Marshall Chambers in the 1870s and 1880s, who at that time was manager of Thorncliffe Ironworks. At the time of the 1911 census, heads of household included coal miners, an assurance agent, an iron foundry foreman and a furnace coke burner.

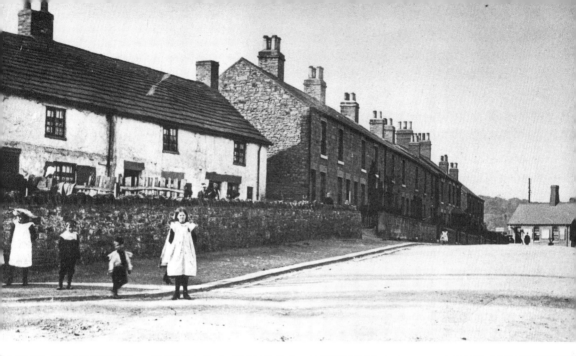

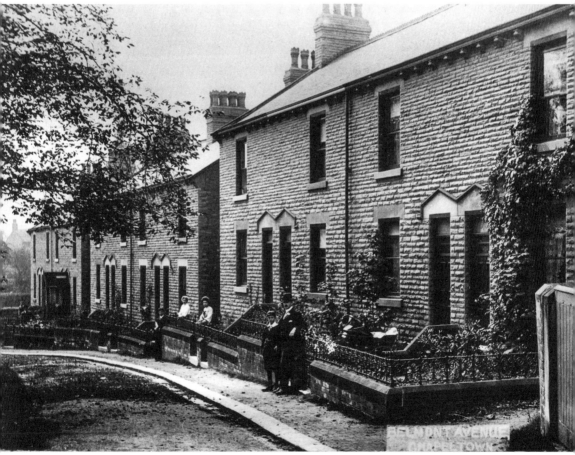

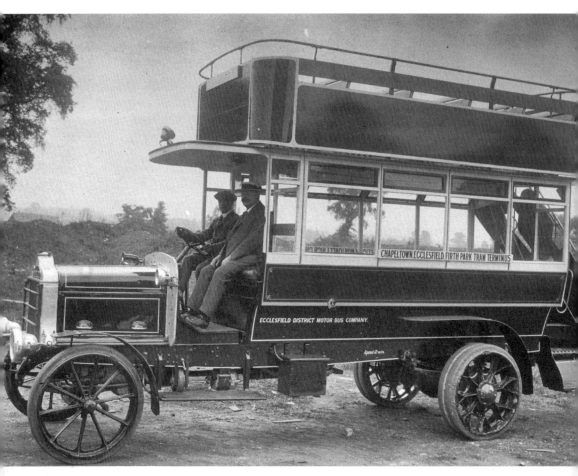

Above: Chapeltown to Firth Park motor bus. This very early motor bus, belonging to the Ecclesfield District Motor Bus Company, was a vital cog in the early motorised public transport service. As the board on the window points out, the route followed by the bus linked Chapeltown and Ecclesfield with the electric tram terminus at Firth Park. This terminus was opened at the bottom of Bellhouse Road in 1909, and gave direct access to the centre of Sheffield via Fir Vale.

Opposite above: Chapeltown Midland Railway station. There were two railway stations in Chapeltown in the past. The Great Central Railway's station, dating from 1855, was up White Lane, the line approached from the south via a bridge over White Lane. It closed in 1953. The Midland Railway's station was opened in 1897 at the junction of Sussex Road and Arundel Road. This is the line that survives to this day. In the background is the bridge carrying Arundel Road.

Opposite below: Thorncliffe Rows. These terraced rows were constructed in the 1860s to house 'blackleg' miners and their families during strikes and lock-outs at Newton Chambers' collieries. There was a six-month lock-out in 1866 and a seventeen-month lock-out between March 1869 and August 1870. On 29 April 1869, a gang of 200 striking miners attacked the cottages, smashed windows and caused the small police contingent to go into hiding. The rows were demolished in the 1960s.

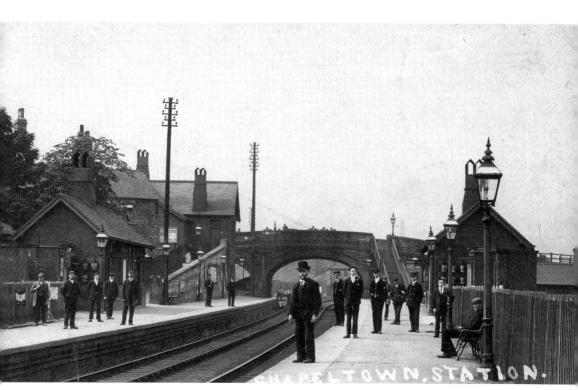

CHAPELTOWN. STATION.

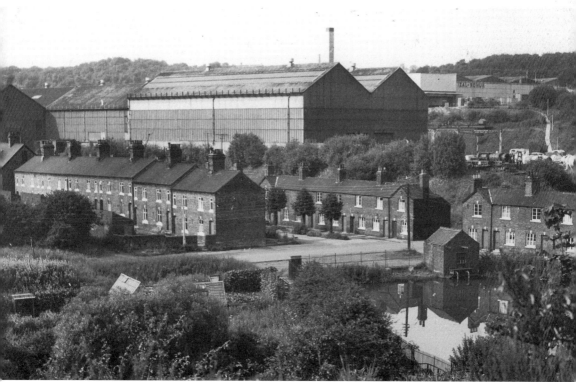

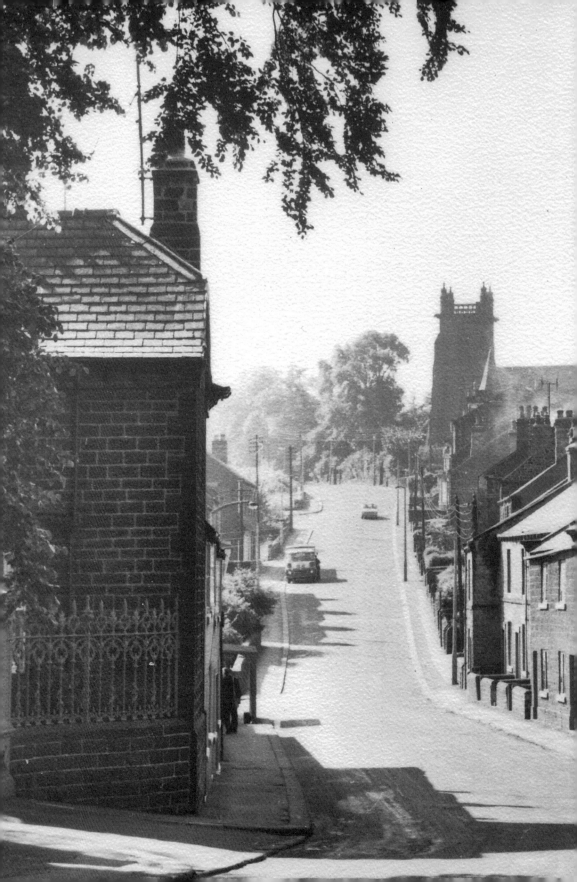

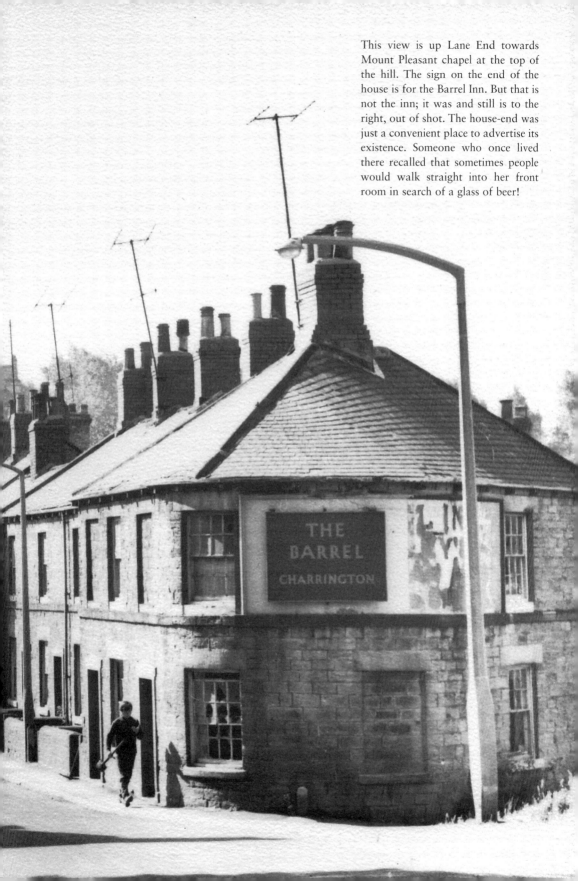

This view is up Lane End towards Mount Pleasant chapel at the top of the hill. The sign on the end of the house is for the Barrel Inn. But that is not the inn; it was and still is to the right, out of shot. The house-end was just a convenient place to advertise its existence. Someone who once lived there recalled that sometimes people would walk straight into her front room in search of a glass of beer!

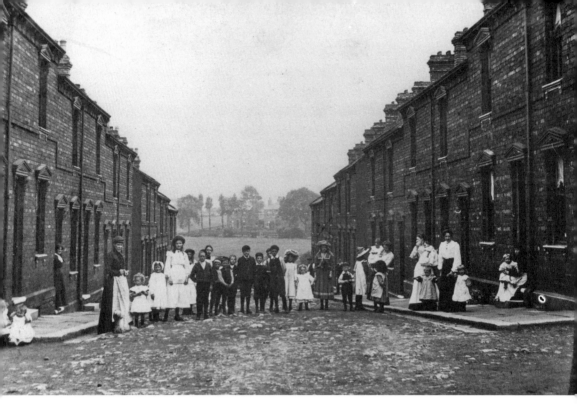

Above: New Street, High Green. In this scene on New Street in the early 1900s, the women and children, all neatly dressed, pose for the cameraman. Jean Huddlestone, who published her memoirs in 1995, remembered regular visits to a house in the street in the 1920s when she was a little girl. She remembered that the front windows were tidily curtained and, as shown here, the edges of the steps and the window sills were whitened. The front doors were seldom used except for funerals!

Opposite above: Joseph Hutchinson outside the old Cart & Horses. As the populations of Ecclesfield, Chapeltown and High Green expanded in the nineteenth and early twentieth centuries, so did every means to provide goods and services. Fruit and vegetables were not only available in specialist shops and the open-air market but also from travelling fruit and vegetable sellers, like Joseph Hutchinson with his horse-drawn cart. The man with a black face, second from the left behind the cart, looks as if he has just come off shift at a local colliery.

Opposite below: Mortomley Hill shops. This view of the shops on Mortomley Hill was taken around twenty-five years ago. Standing on the left is Don Pinkney, who owned High Green Auto Spares and car servicing bay. On the right is Rowland Lowery (Mr Chips) who ran the Fish n' Chips shop.

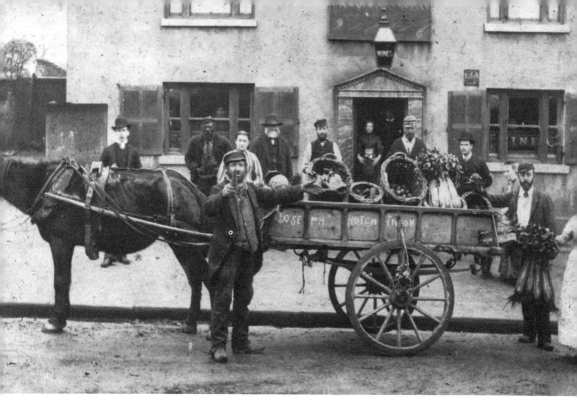

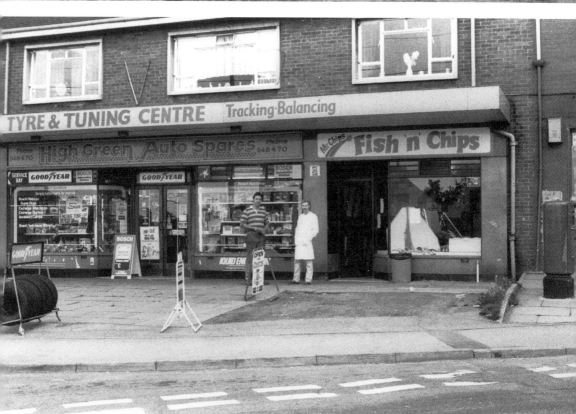

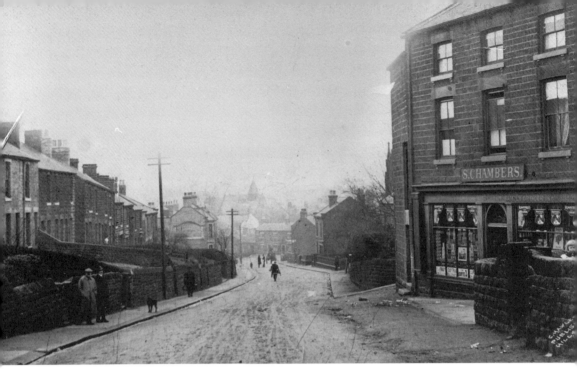

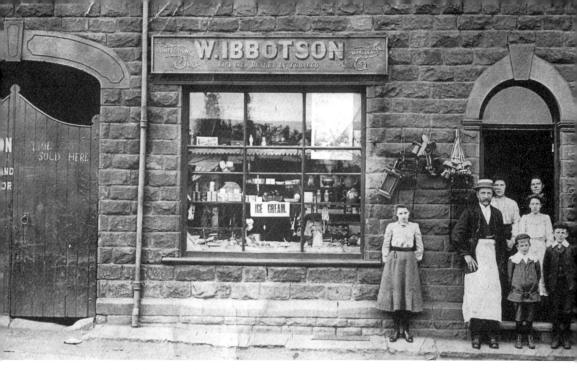

Above: Walter Ibbotson's shop, Wortley Road, High Green. Mr Ibbotson stands in the doorway of his shop with his family in around 1905. Mr Ibbotson was a jack of all trades. The sign in the window says he sells ice cream, beside his name it states that he is a confectioner and general dealer, and below his name it says he is a licensed dealer in tobacco. He also had a wagonette business, transporting people and goods to and from railway stations and other local destinations.

Opposite above: Wortley Road, High Green. Those were the days – so little traffic that you could walk down the centre of the road, or stand in the middle and have a conversation! Sydney Chambers ran the grocery store on the right. He was also a wine and spirit merchant and a sub-postmaster.

Opposite below: Edwin Worthey's shop, High Green. This was a gentlemen's and ladies' outfitters shop. The sign on the blocked-up window next door states that he was also a boot merchant. He had businesses at Chapeltown, Hoyland Common and Royston. He retired in 1923 and died in 1931. He was a respected member of the community, said to be 'Worthey by name and worthy by nature'!

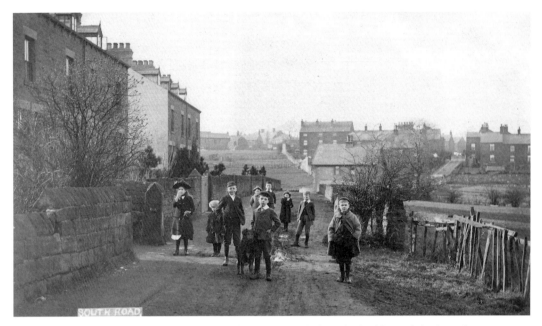

South Road, High Green. In the early years of last century, before the building of the large housing estates that now surround it, a group of children and a dog pose for the photographer in South Road. In the middle and right background can be seen the cottages at Piece End.

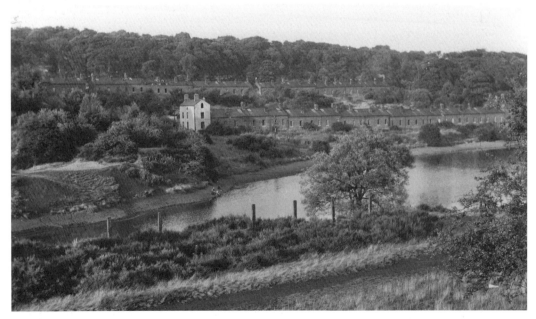

Westwood Rows and Westwood Dam. Westwood Rows, like the Thorncliffe Rows, were built by Newton Chambers to house blackleg labour during their mining disputes in 1869/70. On 21 January 1870, a large crowd of striking miners armed with picks, pistols and spiked bludgeons attacked the rows. Twenty-three miners were sent to York Assizes for trial. The rows were demolished in the late 1960s. The dam was constructed by Newton Chambers to supply the ironworks. The whole area is now a country park.

Churches, Chapels & Schools

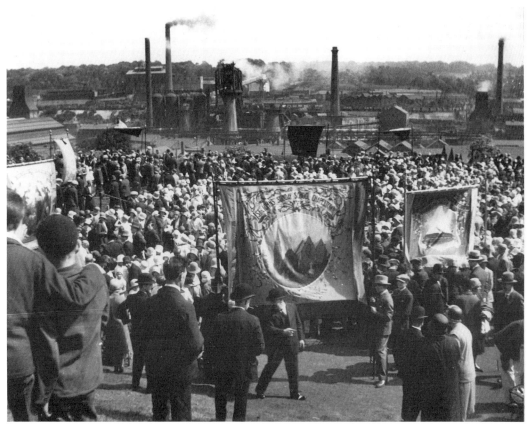

Whit Sing at the 'Ten Acre'. This annual celebration by High Green and Chapeltown churches and chapels in the Ten Acre field, with the puthering smoke from Thorncliffe Ironworks in the background, brings to mind William Blake's memorable lines 'And was Jerusalem builded here. Among these dark Satanic mills'. The large banner is that of St John's Sunday School, Chapeltown.

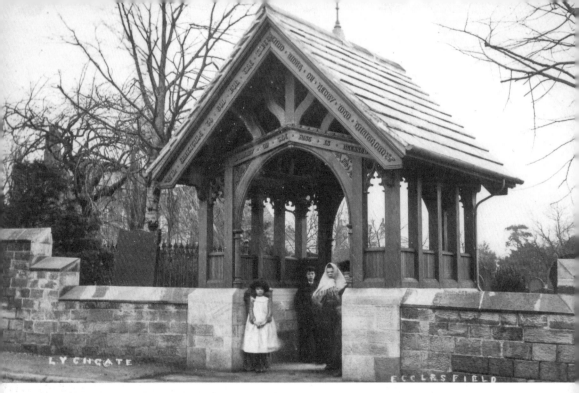

LYCHGATE ECCLESFIELD

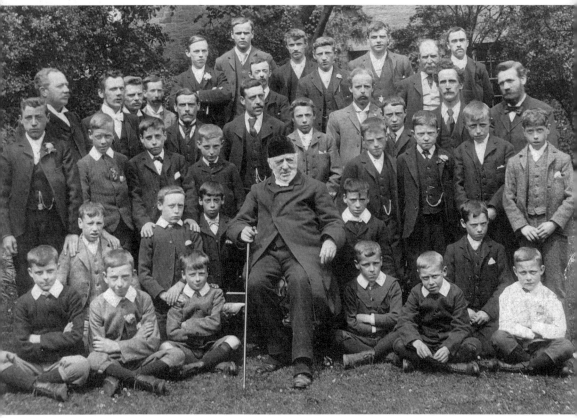

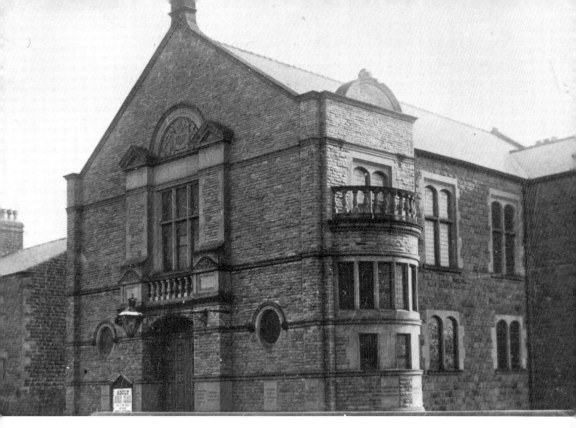

Above: The Wesleyan chapel, Ecclesfield. In 1743 the vicar of Ecclesfield reported to the Archbishop of York that there were four or five Methodists in the parish of Ecclesfield. He went on to say that 'I do not expect the Methodists to last very long'. He was wrong. This chapel, which closed recently, was opened in June 1898, replacing an earlier chapel that opened in 1818. It was built in the Renaissance style and was designed to accommodate about 750 worshippers.

Opposite above: The lychgate at St Mary's church, Ecclesfield. A church lychgate is so called from the Anglo-Saxon word for a corpse. This was where the dead body entered the churchyard on its way to the church for the funeral service. This lychgate was built in memory of the village doctor, Dr Henry Hawthorn, born in 1838. At the time of the 1871 census, he was living in Church Lane with his two unmarried sisters. He lived and worked in Ecclesfield for the rest of his life.

Opposite below: The choir of St Mary's church, Ecclesfield, *c.* 1890. The Revd Dr Alfred Gatty, vicar of Ecclesfield from 1839 to 1903, sits with the St Mary's church choir outside the vicarage in the early 1890s after a Whit Sunday service. In his autobiographical work, *A Life at One Living*, Dr Gatty wrote that every year the choir had 'a trip to the sea, or elsewhere, with a dinner, for which the offertories pay'.

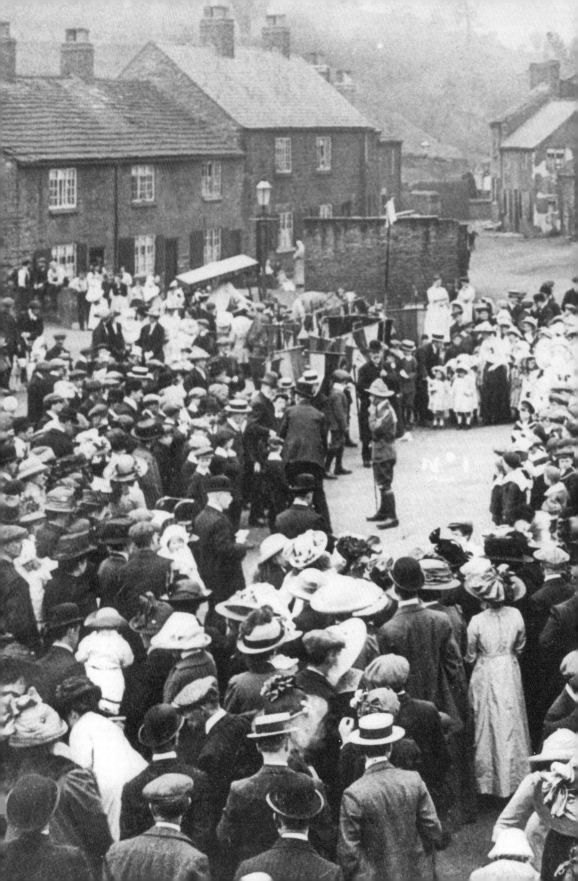

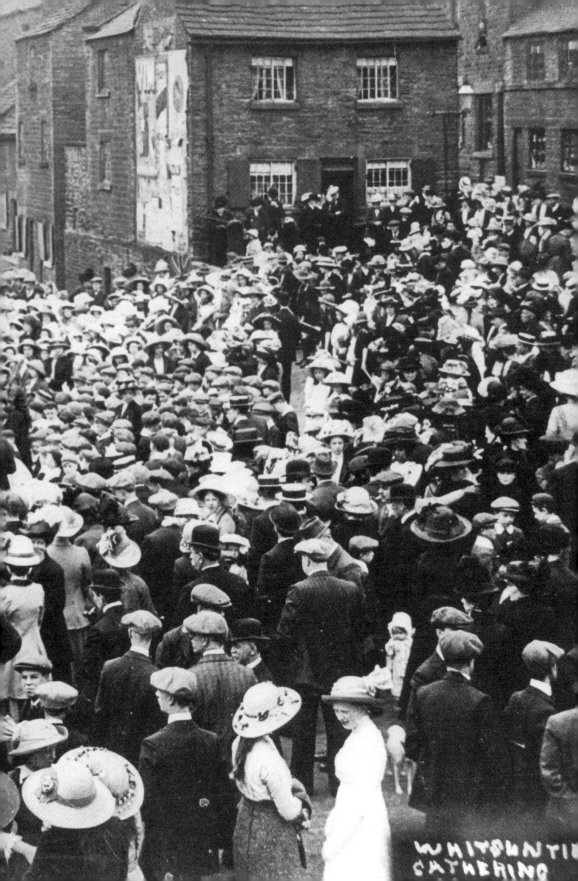

WHITSUNTIDE
GATHERING

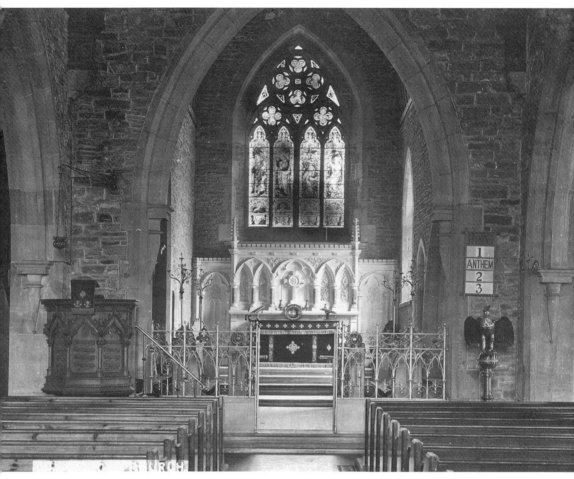

Above: St John's church, Chapeltown. The church of St John was erected in 1859/60 in the Early English style and enlarged and renovated in 1900/01. It closed in March 2000 due to subsidence. The Parochial Church Council decided it had 'come to the end of its life' and that it would be 'poor stewardship to attempt to restore the church building'. Church services were moved to the Newton Hall. In fact, the building has been sympathetically restored and is now a business headquarters.

Previous page: Whit Sing, Stocks Hill, Ecclesfield, 1919. The Whitsuntide Sings on Stocks Hill at Ecclesfield, at Whitley Hall and on the Ten Acre field at Thorncliffe were once among the main social events in the district. In the one shown here, despite the closed-in setting, even including outside privies, everyone is dressed to the nines with the ladies in their wide-brimmed, decorated hats and some of the men sporting bowler hats and straw boaters among the flat caps.

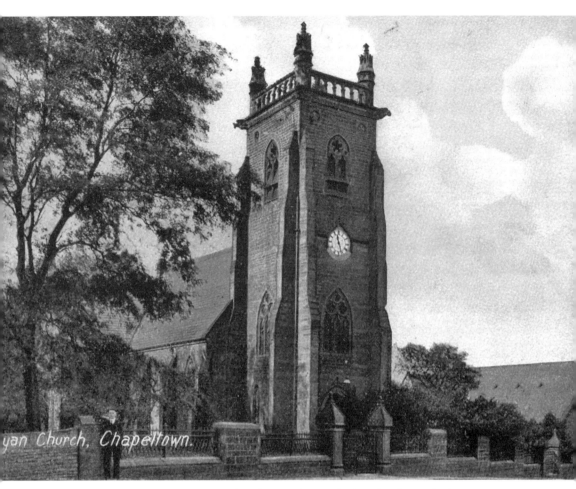

Mount Pleasant Methodist chapel, Chapeltown. This Methodist church was built in 1866 on the site of an earlier chapel, which was built in 1806. The foundation stone was laid by Thomas Newton of Newton Chambers, who was a staunch Methodist. In 1906, on the centenary of the first chapel, bells and a clock were installed in the tower at a ceremony performed by Mrs Freda Newton, and the clock was called Freda by generations of local people. The building has now been converted into living accommodation.

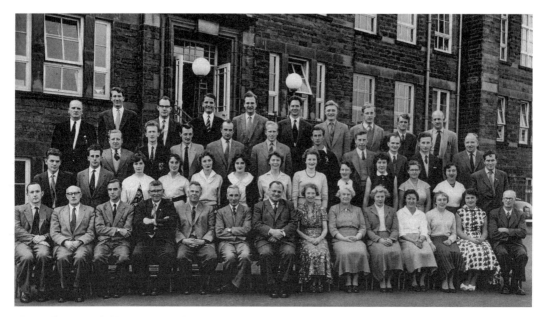

The staff at Ecclesfield Grammar School, 1960. Ecclesfield Grammar School was officially opened on 28 September 1931 by Lady Mabel Smith of Barnes Hall. It cost £33,000 and could accommodate 470 pupils. Seen here are members of the academic staff in 1960. In the middle of the front row is Mr Arnold Jennings, the second headmaster. He became head in January 1959 on the retirement of the first headmaster, Mr A. C. Harrison. The school became a comprehensive in 1967.

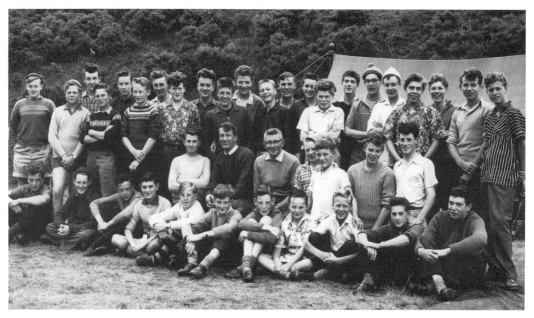

Camping expedition to Hawick, c. 1960. For many years, teacher Mr Richard (Dick) Endall (centre, wearing glasses) organised camping expeditions from Ecclesfield Grammar School to Hawick in the Scottish borders. This group of happy campers was photographed at their campsite in around 1960. Camping was just one of the many extra-curricular activities organised by the school staff, others included a debating society, a square dancing club and a works visit society.

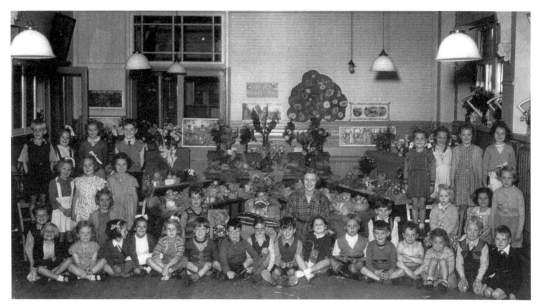

Harvest festival at Burncross Infants, 1953. This class of infants sits proudly in front of their colourful display of fruit, vegetables and flowers at the annual harvest festival. In the middle, wearing a check dress, is class teacher Miss Walker. One of the authors of this book, then Joan Gregory, is on the back row on the left, next to the end, wearing a long white ribbon in her hair!

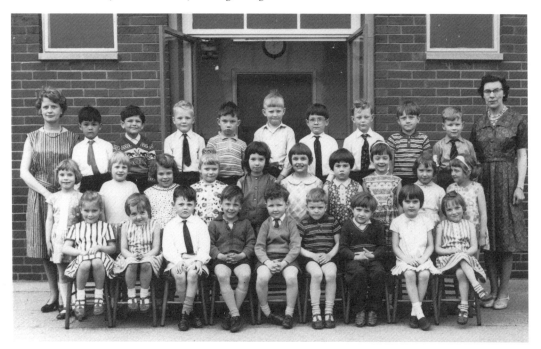

Infants class, Burncross School. This very smart group of infants at Burncross School, with half the boys wearing ties, was photographed in the early 1960s. On the left is class teacher Miss Harris and, on the right, head teacher Miss Joyce Green. Burncross School opened in 1885 and closed in 1994. The site is now occupied by a small modern housing estate.

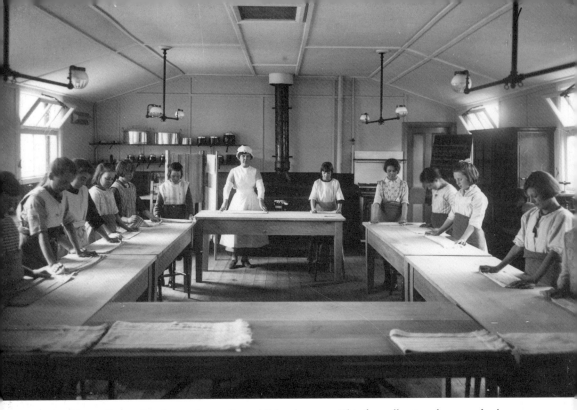

Above: Domestic science class at Lound School, 1920s. This formally staged scene of a lesson in the domestic science room at Lound School dates from the 1920s. The teacher, with her cap, gown and detachable sleeves all in white, looks more like the cook in a big house than a school teacher. The photograph was taken from a glass negative produced by village photographer Arnie Greaves (1866–1934), who walked to every assignment with his camera equipment and tripod over his shoulder.

Opposite: Burncross School's rocking horse. It is a wet playtime in the 1930s at Burncross School. So what better to do than to ride on the school rocking horse still wearing your wellies? In the saddle waving his whip is Eric Green. Patiently waiting her turn is Mollie Dalby, who became Mollie Bintcliffe.

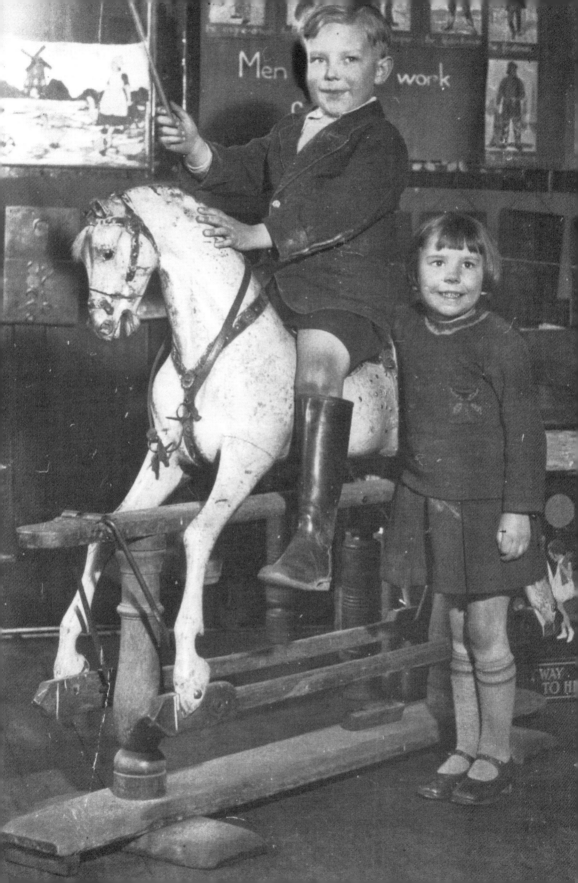

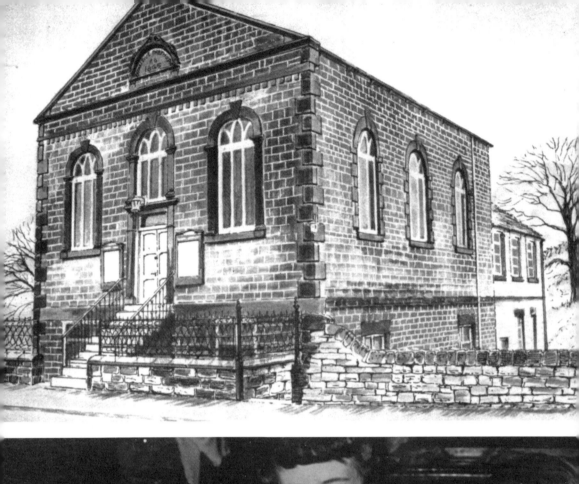

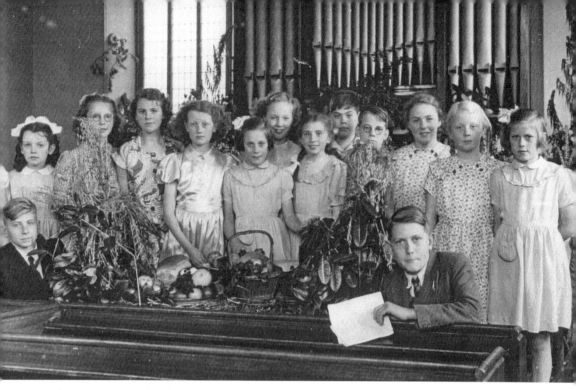

Above: Burncross chapel harvest festival. The harvest festival always took place on the first Sunday in October. Members and scholars took gifts of fruit, vegetables and flowers, which were displayed behind the altar rail in front of the organ. It was at the harvest festival that the Sunday school queen was crowned. After the festival, the produce was auctioned and the proceeds put in the chapel funds.

Opposite above: Burncross chapel and Sunday school. Burncross Primitive Methodist chapel was opened in 1865. Below the chapel, the building accommodated the only school in the Burncross area until the Burncross Board School was opened in 1885. Only children under seven years of age were enrolled. At an inspection in the 1880s, one pupil teacher was found to be 'poor at both her own lessons and in her teaching capabilities'. The room was later used as a Sunday school. The building was demolished in 1992.

Opposite below: Sunday school scholars from Burncross chapel. Another anticipated event at the chapel was the annual Autumn Fair. Members and Sunday school scholars had stalls selling embroideries, handicrafts and homemade jams and chutneys. Seen here in the late 1950s are children playing a game in the hope of winning a small prize. They are, from left to right, back row: Richard Bailey and Mavis Burrows; front row: John Haslam, David Haslam, Kathryn Thompson and Joan Thompson.

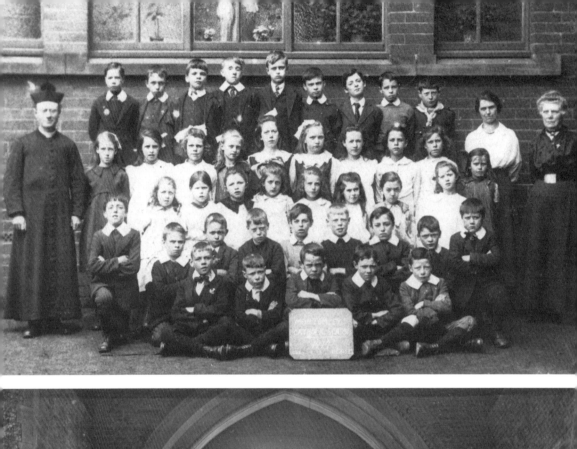

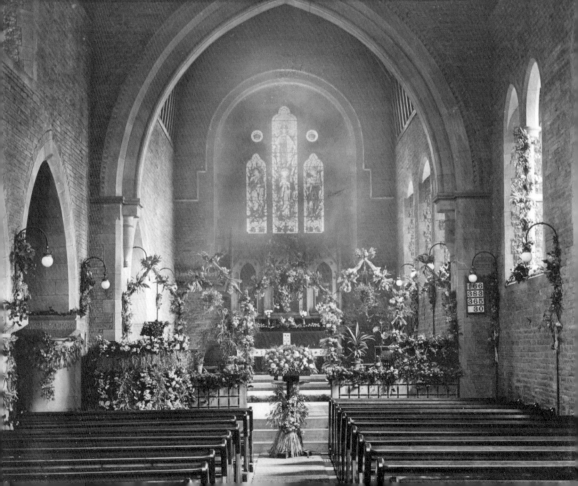

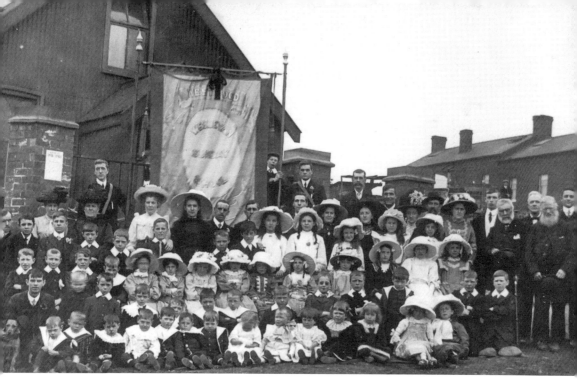

Above: Group at Westwood Rows Mission. Members of Westwood Wesleyan Mission Sunday school pose with their banner in the early years of the twentieth century. Everyone is dressed in their Sunday best, with large hats being worn by all the girls. No one was left out; there is even a dog in the front row. The Mission church can be seen behind the banner.

Opposite above: Class at Mortomley Roman Catholic School, 1919. A Roman Catholic primary school was opened in 1886 as part of the church buildings at the same time as the original Roman Catholic church. By 1889, there were ninety-four pupils. The church and school were built on a site presented by the owner, the Duke of Norfolk. A new school, separate from the church, was opened in 1907. Standing on the left in the photograph is parish priest Father Willibrord Donkers.

Opposite below: Interior of Mortomley St Saviour's church. The church was built in 1872 as a memorial to Parkin Jeffcock, mining engineer, who died while trying to rescue miners trapped in the Oaks Colliery at Barnsley, after an explosion on 12 December 1866. He died in the second explosion on 13 December. Parkin Jeffcock was the elder son of John and Catherine Jeffcock of Cowley Manor. At the laying of the church foundation stone, Dr Gatty, vicar of Ecclesfield, said that Jeffcock was 'the collier's friend'.

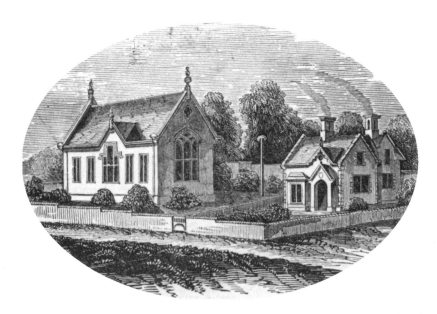

High Green Primary School and Mechanics' Institute. The foundation stone was laid by the Earl of Wharncliffe in 1842, and the school opened in 1843, as both a day school and an evening school for 'youths engaged as miners and artisans'. The master's house, shown on the right, was built shortly afterwards. A contemporary report stated that it would 'furnish a most comfortable residence for those who may have the honourable, although toilsome, task of training the rising generation'.

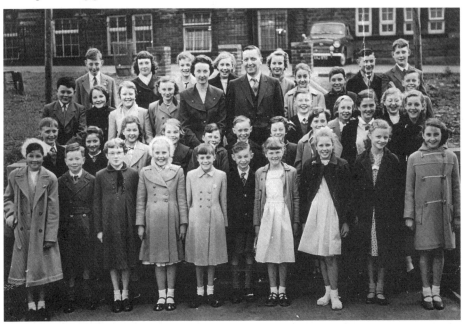

High Green Junior School choir, 1958. This choir took part in the Ecclesfield Music Festival on several occasions and gained first prize in 1958. Here they are with Miss Davison, pianist, and Mr Langston, conductor. Fred Langston became head teacher in 1955, and he and his family lived in the house beside the school shown in the previous photograph until 1965.

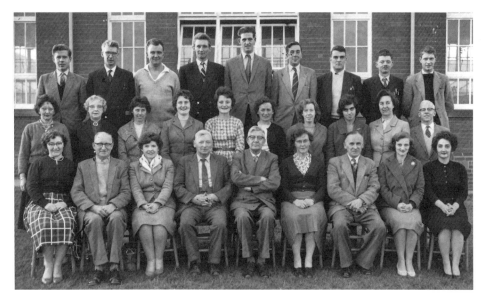

High Green Secondary Modern School staff. This school, on Greengate Lane, now a primary school, was originally built as a senior school for boys in 1928. After the 1944 Education Act, it became a mixed secondary modern school. Shown here are the staff in October 1960, with the head teacher, Frank Piper, seated in the middle of the front row. The school had a high reputation, not only academically, but also in music, sport and handicrafts.

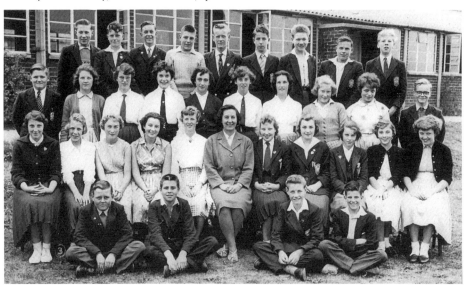

High Green Secondary Modern School class. In around 1960, Miss Joan Gradwell poses with her class. From left to right, back row: Terence Armitage, Robert Wild, John Davy, Michael Wallace, Brian Furniss, Martin Dransfield, Norman Turton, Anthony Sorsby and Michael Cooke. Next row: Geoffrey Rhodes, Shirley Whittington, Madge Webster, Jane Wright, Audrey Childs, Jennifer Askham, Julie Backhouse, Margaret Prior, Juliet Brightmore and Roger Wilkinson. Sitting: Roslyn Sharpe, Joy Howarth, Pauline Catton, Jennifer Cooke, Gillian Naylor, Coral Burrows, Lynne Travis, Christine Hill, Gloria Hible and Pauline Yeardley. Front row: Richard Corfe, Terry Needham, Malcolm Cooper and Paul Davis.

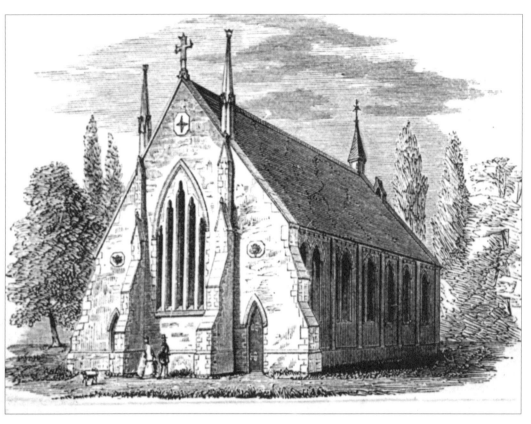

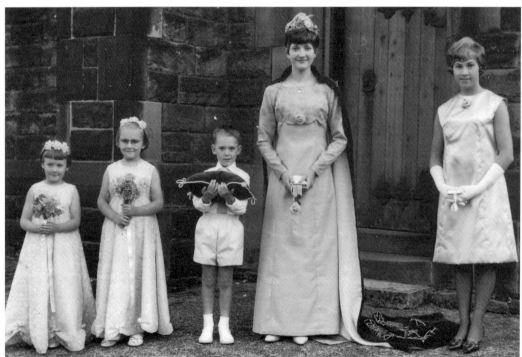

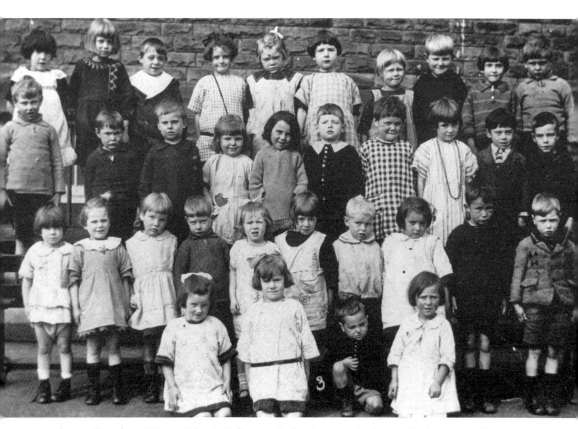

Above: Class from Warren School. Reflecting the hard economic times, this photograph shows a class at Warren School in the 1920s. Warren School, now demolished, stood on White Lane opposite the Norfolk Arms, and on the site now stands a residential nursing home. The school was built in 1900 to accommodate 268 junior children and 100 infants, at a cost of £5,825.

Opposite above: High Green Wesleyan chapel, Wortley Road. The foundation stone of this chapel was laid by Mr George Chambers, colliery owner, of High Green House, in June 1863, and the chapel was opened in March 1864. It is in the Early English style and was designed to accommodate 500 worshippers. It celebrates its 150-year anniversary in 2014.

Opposite below: High Green Wesleyan chapel Sunday School Queen. This Sunday school Queen in the 1960s is Andrea Lynam. Her attendant, on the right, is Jean Shaw (now Jean Howe). On the left, the small boy holds the cushion on which the crown rested before the investiture ceremony.

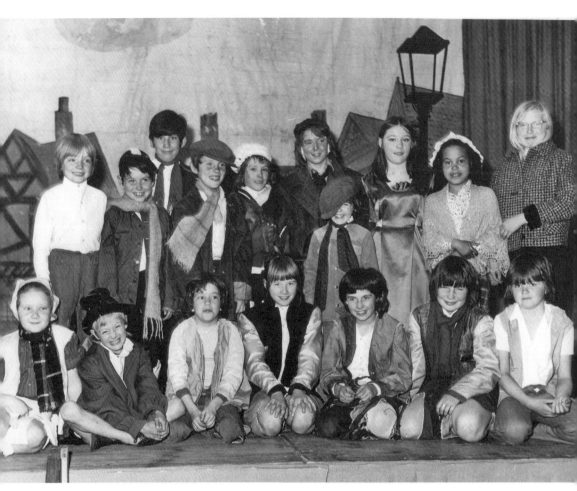

Cast members of *Oliver* at Angram Bank School, 1974. Angram Bank Junior School opened in 1971 to serve the new Angram Bank estate and the Potter Hill area of High Green, under head teacher Mr Ken Kingsley. This musical production was under the direction of deputy head Mrs Iris Idle. At this time, the school was noted for its successful musical productions, Christmas concerts and nativities.

People

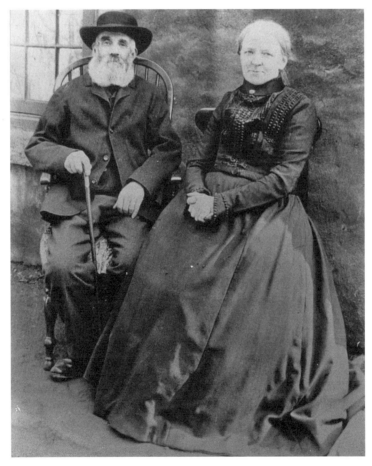

Mr and Mrs Vernon of Warren Lane, Chapeltown, *c.* 1910. William Vernon is notable on two accounts. It was he who blew the buzzer at Tankersley Colliery (he was the engine 'tenter' there) in January 1870 to warn troops that riots were taking place on the Westwood Rows during the Thorncliffe 'lock-out'. He hid under the floorboards when the rioters attacked the pit. His second claim to fame is that he also ran the first co-operative store in the district.

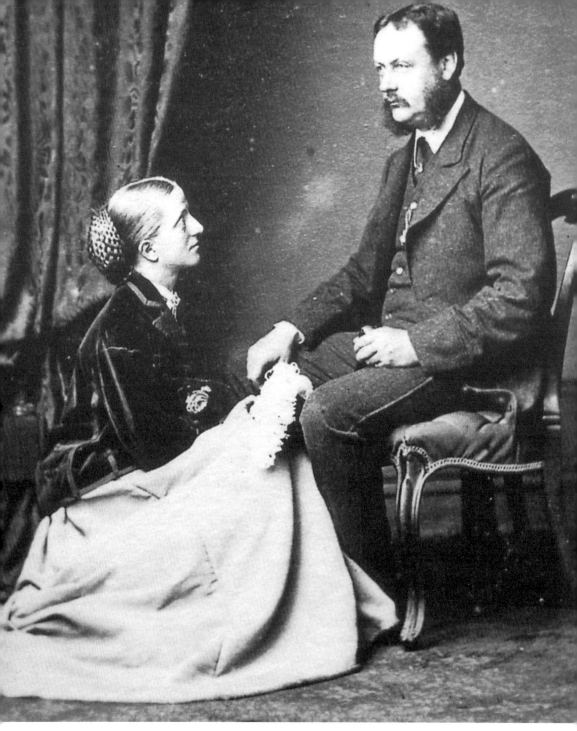

Juliana and Alexander Ewing. Juliana Ewing (née Gatty), second daughter of Alfred Gatty, vicar of Ecclesfield, and his wife, Margaret Gatty, poses with her soldier-husband, Alexander Ewing. Juliana was a famous Victorian children's writer. Among her stories are *The Brownies*, a story of elves who do your housework at night if you are kind to them and which was adopted by Lord Baden Powell for the name of the junior girl guides, and *Jackanapes*, on which Rolf Harris' song 'Two Little Boys' is based.

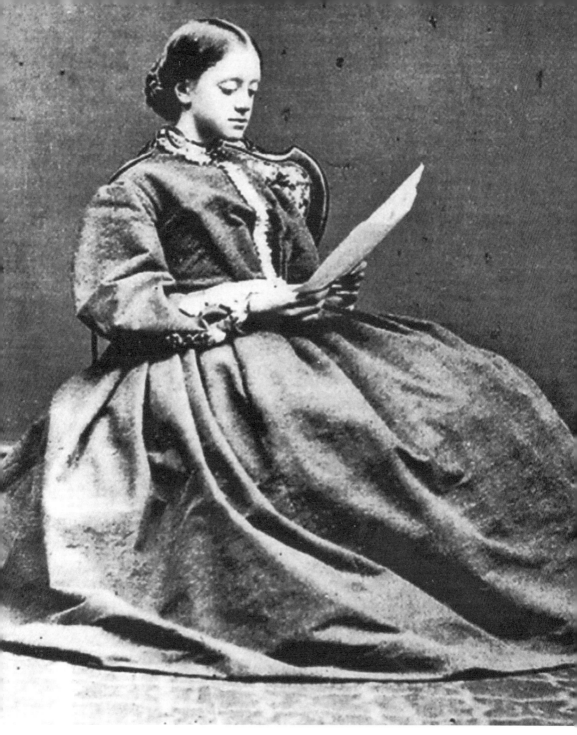

Undine Gatty was the fourth daughter of Alfred Gatty, vicar of Ecclesfield from 1839 to 1903, and his wife Margaret. In this photograph, taken in 1863, she was fifteen years old. She was in Scarborough with her elder sister, Juliana, who recorded in her diary on 28 November that she 'Spent the morning in getting Undine photographed'. Undine married the curate at Ecclesfield, Walter Ward, in 1884. They moved to Australia for seven years but returned because she was homesick for grey stone walls and cloudy skies!

Lucy Moulding of Chapeltown. Lucy was born in 1916, the daughter of Joe and Sarah (née Everitt) Moulding. At the time of her wedding in 1941, she was a packer in the Izal factory. She married Stanley Winkley, who was a colliery clerk for Newton Chambers and then a sales clerk in the Izal factory. They lived on Smith Street and were stalwarts of the Station Road Methodist chapel. They had one son, David.

Redvers Warburton of Chapeltown, looking very smart in his sailor suit in 1910. As a young boy he was taken to the christening of Peter, Viscount Milton, the future 8th Earl Fitzwilliam, in February 1911. He recalled the vast crowds at the event and the fact that he had a hot beef sandwich cut from the beef roasting on a spit – which he said was burnt! He later joined the merchant navy. He lived until he was more than ninety years old.

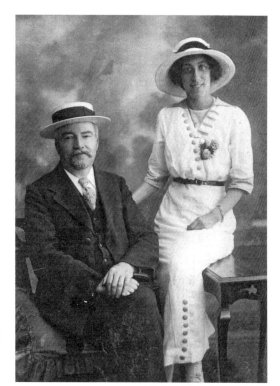

Frank and Alice Senior. Alice was Frank's
second wife. Frank was organist at St John's
church, Chapeltown, for thirty-eight years. He
had a boot and shoe shop on Station Road,
where he also inherited land and cottages. He
had the cottages demolished so that the Picture
Palace could be built (in 1912). This greatly
annoyed his sister, Edith, who was a strict
Wesleyan and disapproved of picture palaces!

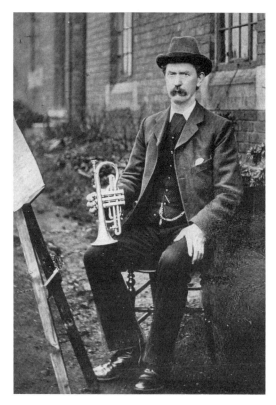

Thomas Edgar Steel of Thorncliffe Avenue,
Chapeltown. This photograph was taken
by Arnie Greaves, the renowned local
photographer. Thomas Edgar Steel and his
wife Mary Ann had a fish and chip shop at
the bottom of White Lane and a grocery shop
on Thorncliffe Avenue. Thomas played in the
Chapeltown Silver Prize Band and also owned
a pony and trap. He died at the early age of
forty-two.

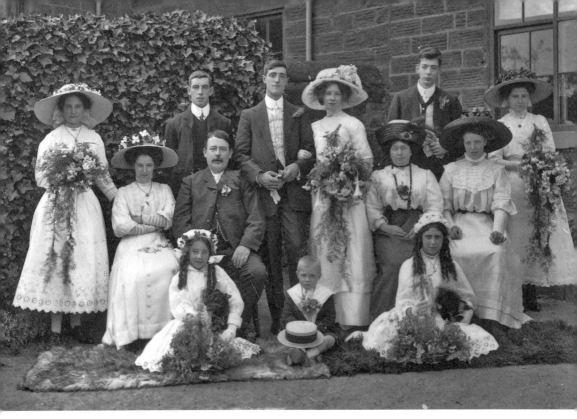

Above: The wedding of Sam Ashworth and Elsie Matthews. This splendid wedding party was also taken by local photographer Arnie Greaves in August 1910, and was printed from a glass negative. Elsie's parents, seen sitting on either side of the bride and groom, kept the Crown & Cushion Inn in Burncross, where this photograph was taken.

Opposite above: The wedding of Edward Ellam and Lucy Smith. This wedding took place in September 1910. The groom was a clerk at Newton Chambers. Lucy became head teacher at High Green Board School. An interesting feature of the photograph is that the photographer, Arnie Greaves again, has tried to obliterate one of the guests, a lodger at the bride's family home, who would have spoiled the composition. If you look carefully in the doorway you can still see his watch chain and polished boots!

Opposite below: The wedding of William Blazey and Minnie Jepson. The wedding of this Ecclesfield couple took place in September 1924. A noticeable change has occurred in the bride's headgear. Gone are the large hats worn by Elsie Matthews and Lucy Smith in the photographs on page 79. Styles had changed between the late Edwardian period and the roaring twenties. And Jessie Jepson, sitting beside the bride, definitely looks of the 1920s.

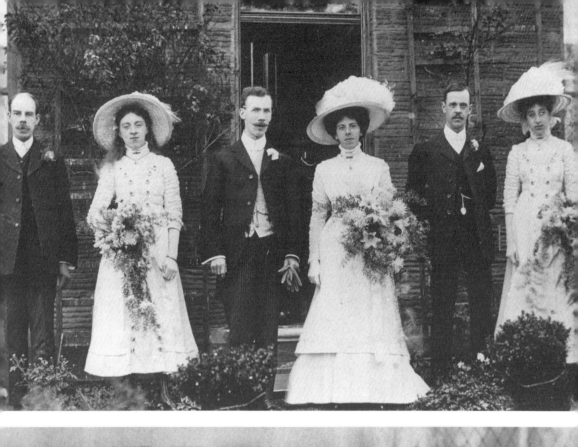

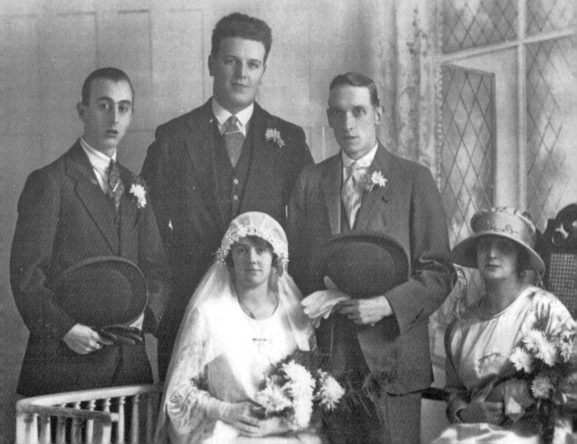

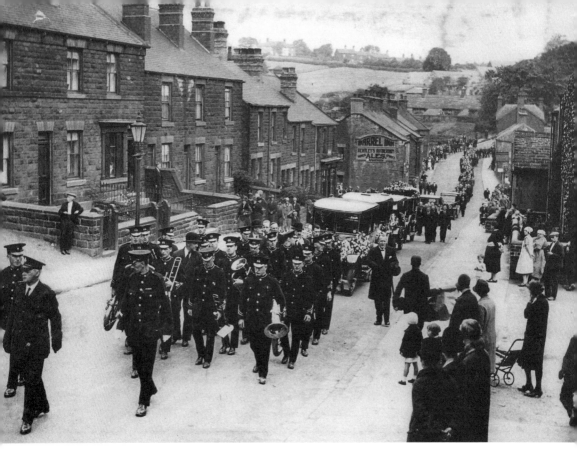

Above: Funeral at Lane End. This funeral procession with marching band and hundreds of mourners was found in the archives of the funeral directors, John Heath & Sons. But they had no record of whose funeral it was or where the photograph was taken. It is taken at Lane End. It may be the funeral in 1919 of Thomas Chambers Newton of Staindrop Lodge, or Thomas Vivian Miles of Lane End House, who died in 1929. He was manager of Thorncliffe Ironworks. We may never know.

Opposite above: Elizabeth Chapman and her daughters. Elizabeth Chapman (née Champion) married Thomas Chapman, filesmith and landlord of the Acorn Inn at Bracken Hill in the mid-1830s. Here she poses with her three daughters (from left to right), Elizabeth, Ann and Sarah, in a watercolour painting, dated 1858. It is assumed that the painter was an itinerant out-of-work artist who perhaps could not pay for his beer!

Opposite below: Mrs Margaret Smith of Barnes Hall and her children. Margaret Scott Smith (née Gatty, 1840–1900) with her nine sons. Margaret married Francis Patrick Smith, lawyer and landowner, in 1868. The sons had varied careers. William (back row, second from left) was the eldest son who married Lady Mabel Fitzwilliam. Godfrey (back row, third from left) became vicar of Wentworth and Francis (standing on the right at the back) became chairman of the United Steel Corporation.

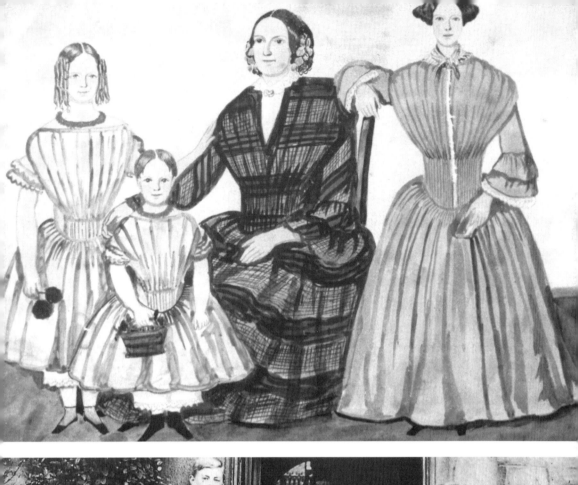
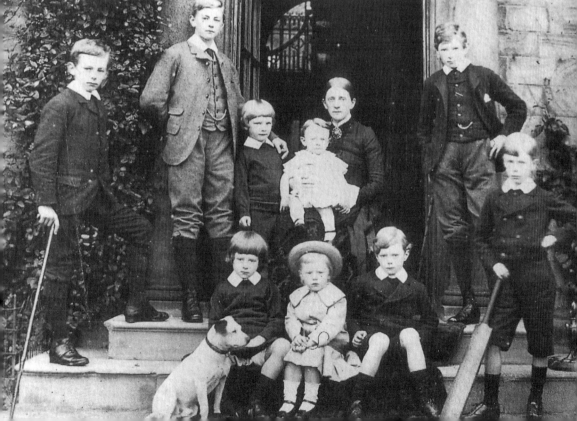

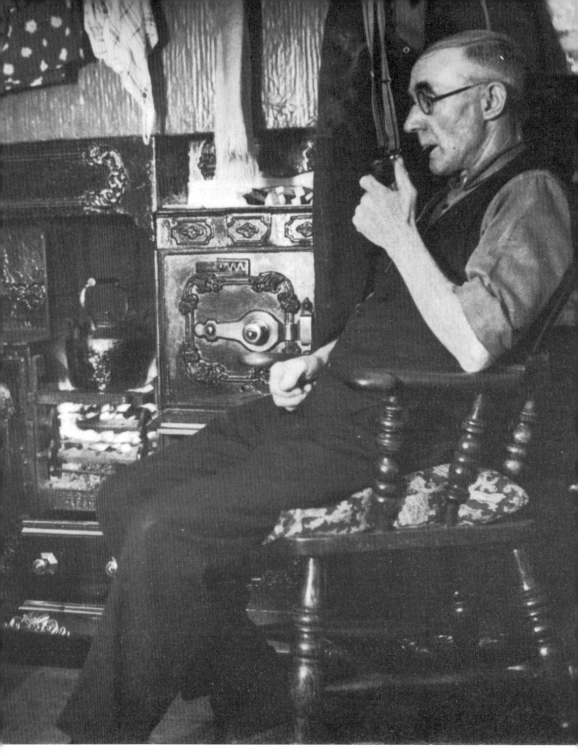

Fireside scene. The workday is over, the evening meal is being digested and this man sits beside a coal fire in his Windsor chair smoking a pipe and waiting for the kettle to boil – and no doubt he was looking forward to his drink of tea in a big mug! The black-leaded cooking range is gleaming, sticks are drying over the oven and clothes are either drying or airing above it.

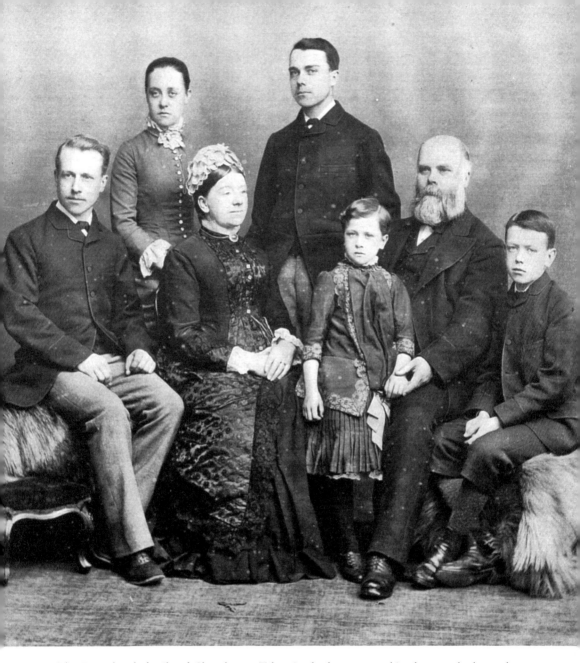

The Barraclough family of Chapeltown. Taken in the late 1880s, this photograph shows the bearded William Barraclough, his wife, Ann (née Milns), three sons and two daughters. At this time they were living at Harcourt Lodge on Cowley Lane. By that time, William was company secretary to Newton Chambers. His son, Charles Edward (extreme left) succeeded his father as company secretary. William Herbert (at the back) became an industrial chemist and Arthur (extreme right) became a general practitioner in Chapeltown.

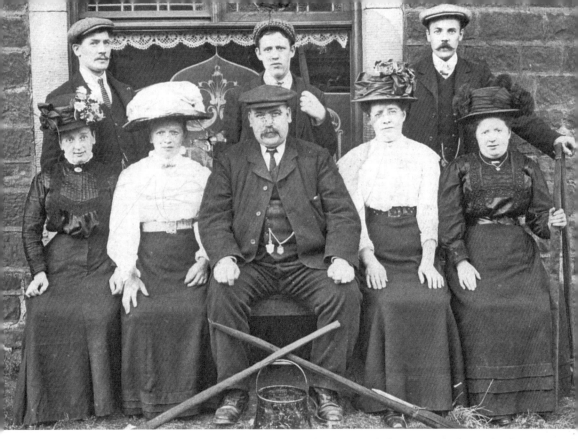

Above: Chapeltown Fishing Club. Fishing has always been a popular pastime, whether on local waterways and ponds or on special excursions to venues in Lincolnshire and Cambridgeshire. Here we see four be-capped anglers from Chapeltown Fishing Club in the early 1900s on an angling outing, accompanied by their womenfolk. The ladies are bedecked in their best hats and the gentlemen are wearing their watch chains in their waistcoats.

Opposite above: Edwardian group of children. This wonderful small group of children are posing very professionally for the photographer during a pause in their game of cricket. All the children can be identified. From left to right: G. Raines, Cyril Faries, Olive Cooper, Madge Burgin and Arthur Sansam. Arthur died in 1981 aged eighty-five. He was the choirmaster at Mortomley St Saviour's church.

Opposite below: Curdew Smith and the Wass children. Mr Curdew Smith is seen here on his ninety-eighth birthday with members of the Wass family. Mr Smith was a retired employee of Newton Chambers' Thorncliffe Ironworks. On his 100th birthday, he was visited by the chairman of the company, Sir Harold West, who presented him with a pipe and two months' supply of his favourite tobacco.

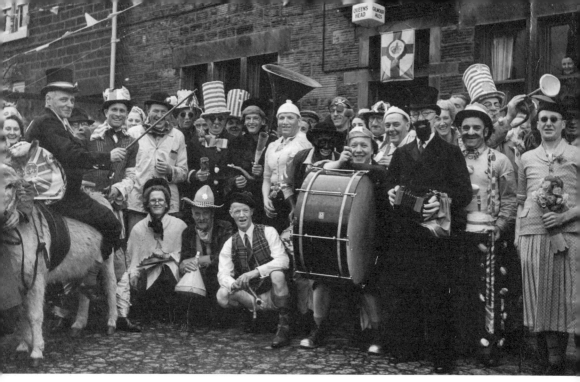

Above: Outside the Queen's Head, Mortomley, on VE Day. This crowd of participants celebrating VE Day at the end of the Second World War in Europe have found or salvaged an amazing array of fancy dress costumes, including those of clowns, a pirate and a Wild West star – and all this to the accompaniment of a selection of musical instruments, including a giant trombone, an enormous drum and a squeezebox. Don't forget the unperturbed donkey on the extreme left!

Opposite above: Silver Jubilee of George V at Charlton Brook. The flags are flying and the bunting is flapping on Stanley Road, Charlton Brook, to celebrate the Silver Jubilee of King George V in 1935. Posing are the residents of Nos 20–28 Stanley Road. Standing, from left to right: Mr Whittaker, Amy Prior, Mr J. W. Prior, Edith Prior, Mr Unwin, Kathleen Unwin, Thomas Prior, Mrs Whittaker, Mrs Unwin and Mrs Prior. Sitting at the front are Grace Prior, Billy Unwin, Violet Whittaker, Phoebe Brook and Charlotte Unwin.

Opposite below: Coronation celebrations, 1937. This group of young girls and boys from the Warren Lane area of Chapeltown were dressing up as part of King George VI's Coronation celebrations in 1937. Fancy dress costumes include a clown, brides and even, on the front row, Darby and Joan.

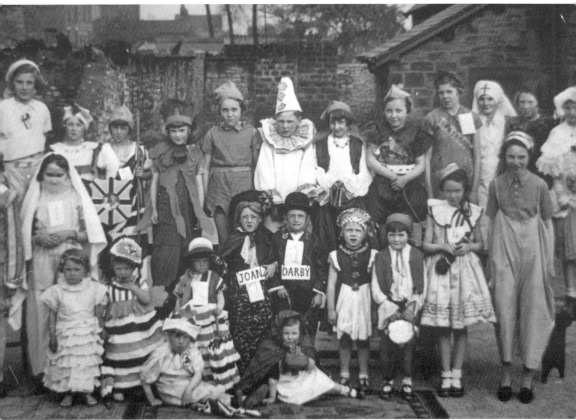

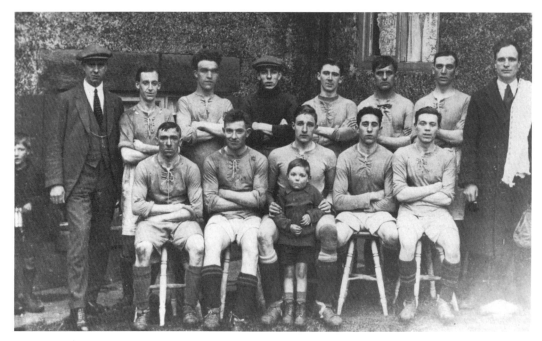

Ecclesfield United football team in the 1920s. The village supported several football teams. Ecclesfield Red Rose has a long history and, for several years, Ecclesfield United were prominent in the Association League. Some members of the team later played professionally. This photograph shows the Ecclesfield United team in the 1920s. Those were the days when the goalkeeper invariably sported a flat cap. The team mascot is Harry Ridge, whose parents kept the Ball Inn where the photograph was taken.

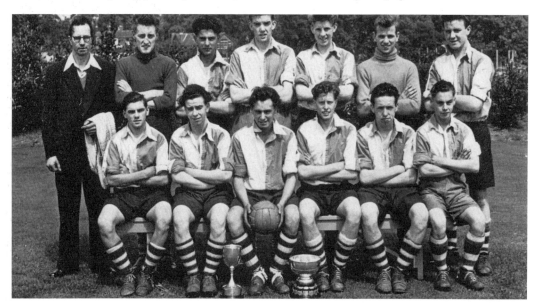

Thorncliffe football team, 1954. Newton Chambers supported a wide variety of sporting and recreational activities. Posing here is Thorncliffe Recreational Association Football Club at the end of the 1953/54 season. As the cup on display suggests, the team had a very successful season being crowned the Sheffield Works Sports Association Drake League Champions.

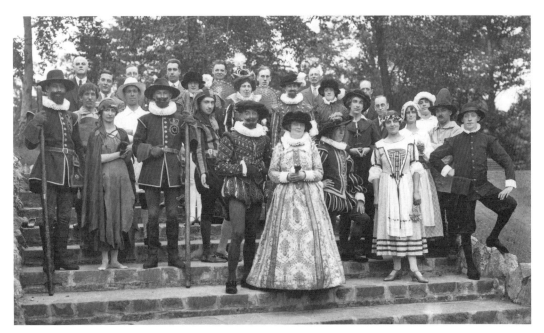

Chapeltown Operatic Society, *Yeomen of the Guard* cast. Dramatic and operatic societies have long been thriving institutions locally, including the still operational Chapeltown Operatic Society, the Priory Players of Ecclesfield and High Green Musical Theatre Group, as well as the now defunct Thorncliffe Musical Society. Here the cast of Gilbert and Sullivan's *Yeomen of the Guard* and other active members of Chapeltown Operatic Society pose in Chapeltown Park.

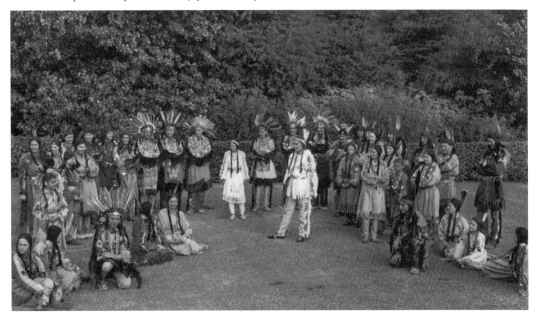

Thorncliffe Musical Society, cast of *Hiawatha*. The nearly forty-strong cast of *Hiawatha*, performed by Thorncliffe Musical Society in 1947, pose in Chapeltown Park. Nothing had been spared to create an authentic-looking cast, including moccasin footwear, costume, hairstyle and headdress. Park users must have been very surprised at seeing this large party of Native Americans so far from home!

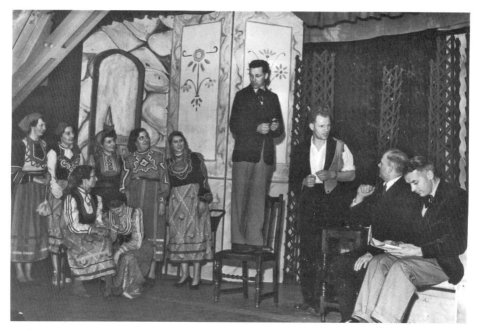

High Green Operatic Society, leading players in *Carissima*, 1954. This production of the musical comedy *Carissima* was held in the Miners' Welfare Hall. It opened to an audience of old age pensioner guests on Tuesday 5 May. By the end of the final performance on Saturday 9 May, it had entertained more than 1,500 people.

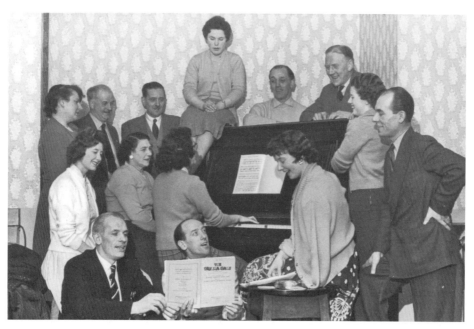

Cast of *The Pajama Game*. With a score by Richard Adler and Jerry Ross, this musical was popular with amateur groups, and was performed by High Green Amateur Operatic Society in 1960. Concerned with labour troubles among female staff at the Sleep-Tite Pajama Factory, it would have gone down well in High Green, especially as it was performed in the Miners' Welfare Hall.

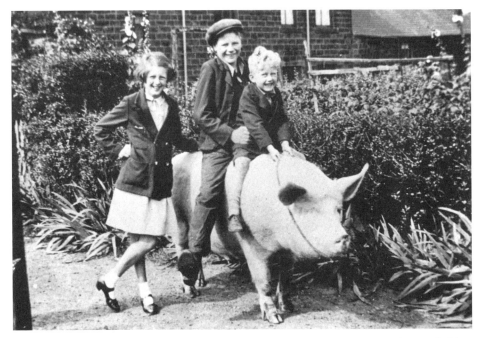

Pig riding! Taken at Lane End, this happy scene shows Derek Moxon (wearing the cap) holding Melvyn Taylor, who holds the reins. Leaning on the pig in a casual pose is Gwen Robson in her smart blazer. Derek Moxon later became a butcher!

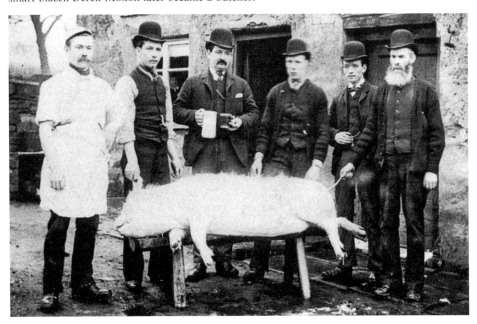

Pig killing at Howbrook, *c.* 1900. Amos Dransfield, the pig killer, is on the left and William Lee is on the far right. The men standing third and fifth from the left look remarkably like Laurel and Hardy! Amos Dransfield was a miner who lived on New Street in High Green. Nothing of the pig was wasted: various pork joints were accompanied by bacon, ham, black pudding, lard, brawn, chitterlings, pig's feet and hocks.

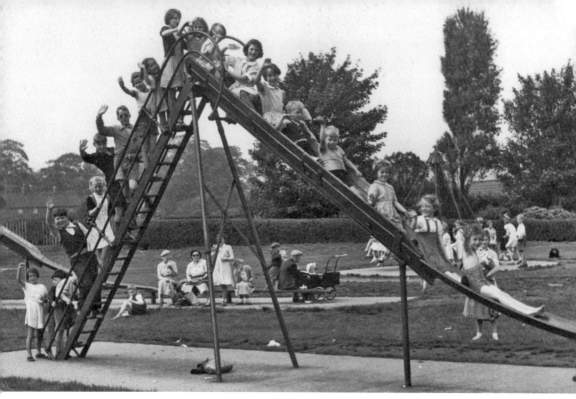

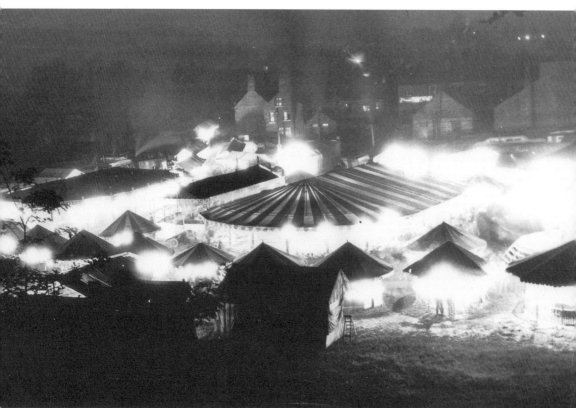

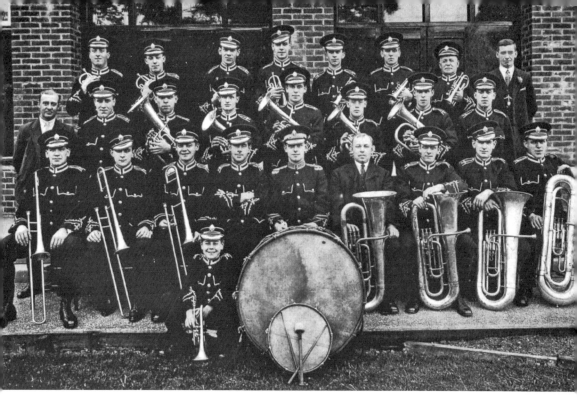

Above: Chapeltown Silver Prize Band. Looking very smart in their new uniforms, the band pose outside the Miners' Welfare Hall in Chapeltown in the 1930s. The band first played in the 1870s and is still going strong, being promoted to the Second Section from January 2012. In 2013, the players ranged in age from thirteen to sixty-seven. Originally most players lived locally but now they come from all parts of Sheffield and some from further afield.

Opposite above: Ecclesfield Park, August 1954. It is a hot day in the middle of the school holidays in August 1954, and what better place to be than in Ecclesfield Park? There is a queue to use the slide, the small roundabout in the background is crowded and parents and grandparents sit and watch and eat their ice creams.

Opposite below: Chapeltown 'feast' at night. This travelling fair, which attracted thousands, was held behind the Coach & Horses public house on Station Road. On entering the fairground there would be stalls offering unpassable eatables, such as brandy snap and toffee apples, and there were slot machines and shooting galleries. Then there were the rides: the steamboats, flying chairs, the carousel, Noah's Ark, waltzers and dodgems. Sideshows included the bearded lady, the boxing booth and sometimes the man putting his head in a lion's mouth!

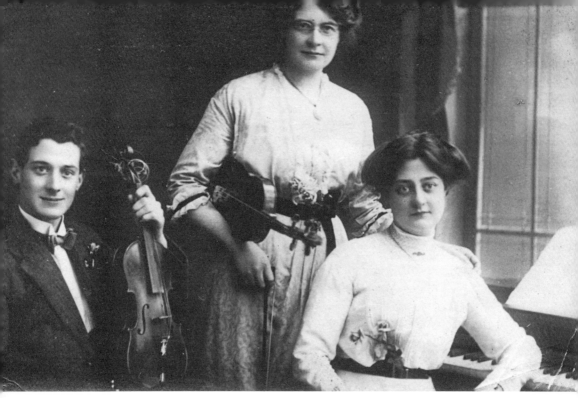

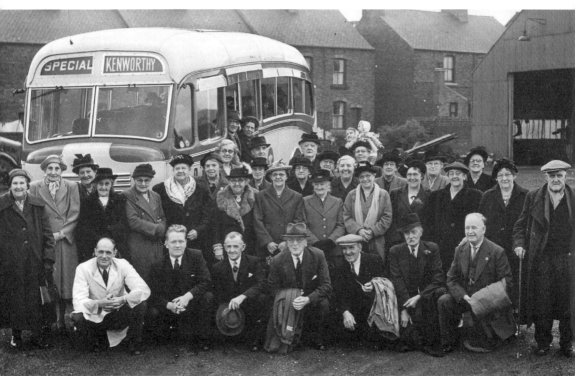

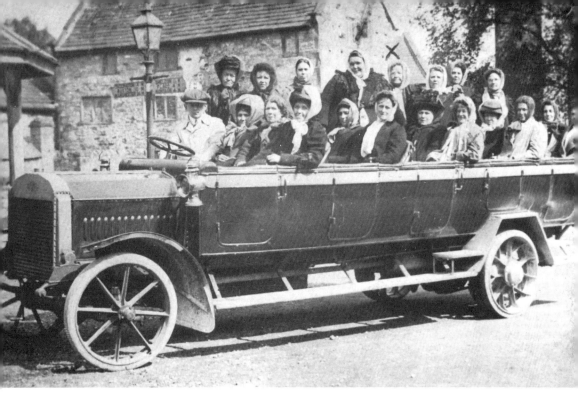

Above: Charabanc trip to Matlock. This party of ladies from Piece End, High Green, look as if they are looking forward to their day out. The charabanc made a big difference to day trips in the first two decades of the twentieth century. There was no need to walk to and from the railway station at the beginning and end of the day and trips could go to destinations far from railway stations, such as Sherwood Forest and parts of the Peak District.

Opposite above: The Dransfield Trio. Daniel Chappell Dransfield, with his sisters Grace (centre) and Lily (right), pose for the photographer in 1915. They were noted musicians who regularly gave concerts in the district. Grace taught at High Green School on Wortley Road and often conducted the Whit Sing on Mortomley Hill. Their father, Daniel, was a stalwart of Stoneygate Methodist chapel in High Green.

Opposite below: Coach trip with Kenworthy's of Chapeltown. The main disadvantage of a charabanc was that there was usually no overhead cover from wet weather, and even if there was, the sides remained open to the elements. Covered motor coaches were a real innovation and the society or club trip in a convoy of coaches became a real treat. Members of this party, equipped with all they need if the weather turned nasty, are outside Kenworthy's garage with Smith Street in the background.

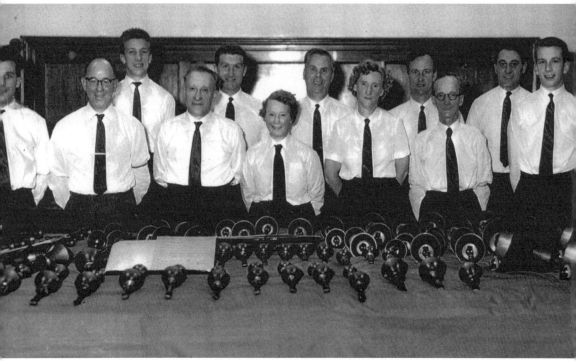

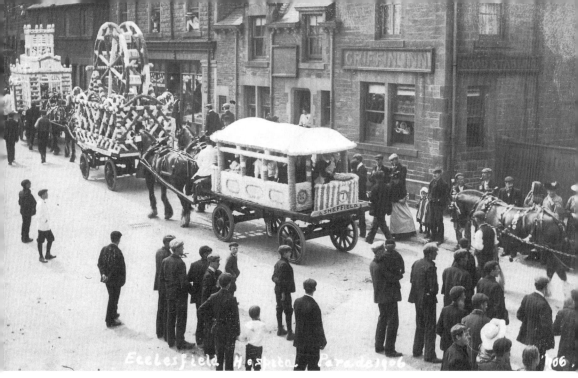

Above: Ecclesfield Hospital Parade. In the days before the NHS was introduced, hospitals depended for a substantial amount of their income on bequests, endowments and public generosity. Ecclesfield mounted an annual 'hospital parade' from the 1890s until the mid-1930s. On this parade, a cavalcade of horse-drawn floats would tour the area accompanied by collectors in fancy dress, who collected money from the public. These three impressive floats have just passed the Griffin Inn on their way to Grenoside in 1906.

Opposite above: Ecclesfield Plough Bullocks. Plough Monday was an old tradition that took place on the first Monday after the twelve days of Christmas. A 'common plough' was kept in the parish church for those in the community who did not own their own. It was blessed by the vicar, decorated and paraded around the parish by plough boys called 'plough bullocks' or 'stots'. The custom was revived in the 1930s in Ecclesfield as part of the annual hospital parades.

Opposite below: Ecclesfield Handbell Ringers, 1960. There has certainly been handbell ringing in Ecclesfield from around 1880 when Thomas Kitson formed a family team. Then, in 1904, Mr Hirst, landlord of the Greyhound Inn, bought a set of sixty-eight handbells and formed the Ecclesfield Handbell Ringers with a group of friends. In 1924, they bought a new set of 170 handbells. Girls were recruited for the first time in 1945 and, in this photograph taken in 1960, Winnie Lester and Eileen Taylor represent the fairer sex.

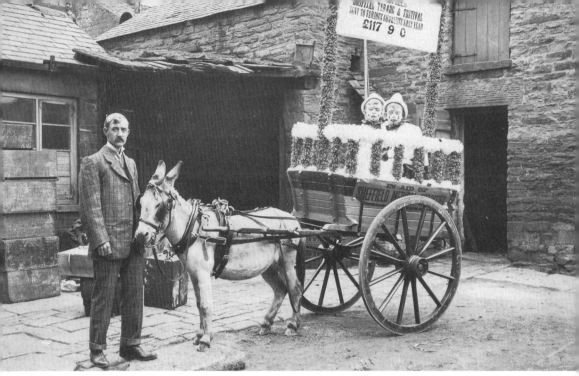

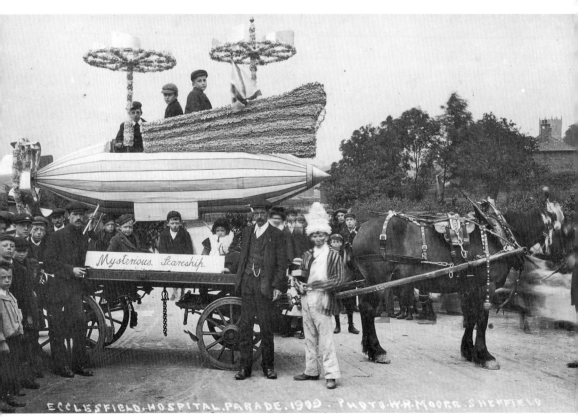

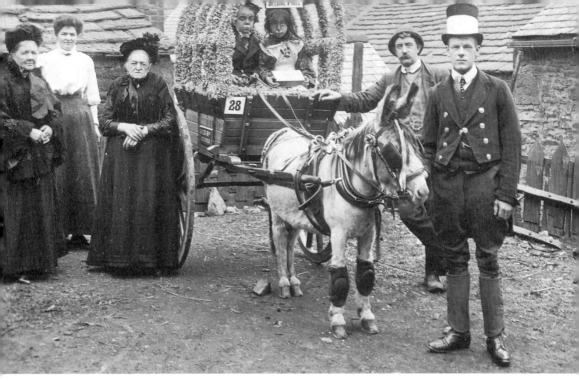

Above: Hospital Parade prize-winning float. Ready for the off is this float from 1909, which had been awarded a special prize. Floats had to be ready for the third Saturday after Whitsuntide. They set off from Ecclesfield Common and went through Grenoside and Wadsley Bridge and past the Royal Infirmary into central Sheffield. The parade then made its way back to Ecclesfield via the Wicker and Firth Park. On Sunday it went off again to Chapeltown, Burncross and High Green and ended up at Chapeltown Feast.

Opposite above: Family float for the Ecclesfield Hospital Parade. Each float was made by a group of families living in a particular group or row of houses. Everything was done in secret because the floats were part of a competition, with the winner leading the whole parade. Once the theme for a float was decided, an expert metalworker or woodworker from within the group would make the frame, which was then cleverly covered with coloured paper and other materials. This small float announces how much money had been collected.

Opposite below: Hospital Parade airship float. Themes for floats varied enormously, from local buildings such as Ecclesfield church, local industries such as quarrying, to more exotic subjects such as windmills and royal coaches. Figures of wild animals also featured regularly. As time went on, more modern subjects made their appearance, such as cameras and aeroplanes. In this photograph from 1909 the 'Mysterious Scareship' is of course an airship.

Acknowledgements

The authors would like to thank the following for the donation or loan of photographs and/or accompanying information: Marian Barraclough, Joan Batten, Ted Bellamy, Michael and Pauline Bentley, Christine Berry, Mollie Bintcliffe, Harry Birkby, John Blazey, Kathleen Booker, Alan Boulton, Mary Bulmer, G. Bywater, Grace Cauwood, Chris and Pete Chapman, Marjorie Copley, Bryan Dawson, G. Driver, Ken Eastman, Stanley Ellam, George Elliott, Jim Ellis, Anne Faries, Doris Faries, Doris Fox, Bryan Franklin, Cherry Gatty-Smith, Anthea and Trevor Greaves, John Greaves, Doreen Green, Conrad Gregory, Ernest Hartley, Jason Heath, Clara Housley, Wilf Hutchinson, Clarice Hyde, Elvy Ibbotson, Amy Jones, Mrs Jordan, Norman Kirk, Shirley Kirk, Fred Langston, Peter Leask, David Lee, Joan Lockwood, Ivan Martin, Mrs North, Godfrey Pell, Vera Perry, Eddie Platts, Harold Rodgers, Mary Salt, Tom Sanderson, Barrie Sharp, Chris Sharp ('Old Barnsley'), Cyril Slinn, Hester Smallbone, Doris Sylvester, Jessie Taylor, Ron Thomas, Kathryn Thompson, Bryan Wadsworth, Redvers Warburton, Vincent Wheeler, David and Jacqueline Winkley and Allan Womersley. We apologise if we have inadvertently omitted the name of any contributor.

References

Eastwood, J., *History of the Parish of Ecclesfield* (Bell & Daldy, 1862).

Habershon, M. H., *Chapeltown Researches* (Pawson & Brailsford, 1893).

Hey, D., *The Village of Ecclesfield* (The Advertiser Press Limited, 1968).

Jones, J. & Jones, M., *'A Most Enterprising Thing': An Illustrated History to Commemorate the 200th Anniversary of the Establishment of Newton Chambers at Thorncliffe* (Chapeltown & High Green Archive, 1993).

Jones, J. & Jones, M., *Picturing the Past* (Chapeltown & High Green Archive, 2004).

Jones, M. & Jones, J., *Ecclesfield, Chapeltown and High Green Through Time* (Amberley Publishing, 2009).

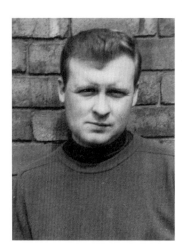
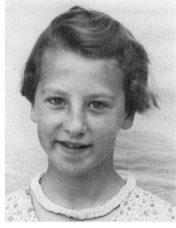

The Authors
... From Old
Photographs!